MASTERS OF PHOTC

THIS IS A GOODMAN BOOK

Text and design copyright © 1999, 2008 and 2013 Carlton Books Limited

This third edition published in 2013 by Goodman An imprint of the Carlton Publishing Group 20 Mortimer Street, London W1T 3JW

First published under the title C20th Photography.

This book is sold subject to the condition that it shall not, by way of trade or otherwise, be lent, resold, hired out or otherwise circulated without the publisher's prior written consent in any form of cover or binding other than that in which it is published and without a similar condition including this condition, being imposed upon the subsequent purchaser.

All rights reserved.

A CIP catalogue record for this book is available from the British Library

ISBN 978 1 84796 059 7

Printed and bound in Hong Kong

MASTERS OF PHOTOGRAPHY

REUEL GOLDEN

CONTENTS

FOREWORD	6	ELLIOTT ERWITT	74
INTRODUCTION	8	ROBERT FRANK	78
BERENICE ABBOTT	12	LEE FRIEDLANDER	80
ANSEL ADAMS	16	FAY GODWIN	84
EVE ARNOLD	20	NAN GOLDIN	88
EUGÈNE ATGET	26	ANDREAS GURSKY	92
CECIL BEATON	30	ERNST HAAS	96
BERND AND HILLA BECHER	34	BERT HARDY	102
MARGARET BOURKE-WHITE	36	LEWIS W. HINE	106
BILL BRANDT	38	CANDIDA HÖFER	112
ROBERT CAPA	42	HORST P HORST	114
HENRI CARTIER-BRESSON	46	ERIC HOSKING	118
ALVIN LANGDON COBURN	50	GEORGE HOYNINGEN-HUENE	120
IMOGEN CUNNINGHAM	54	GRACIELA ITURBIDE	122
EDWARD S. CURTIS	58	NADAV KANDER	124
ROBERT DOISNEAU	62	YOUSUF KARSH	126
TONY DUFFY	66	ANDRÉ KERTÉSZ	130
WILLIAM EGGLESTON	70	WILLIAM KLEIN	134

HEINZ KLUETMEIER	138	GEORGE RODGER	21
NICK KNIGHT	142	WILLY RONIS	21
DOROTHEA LANGE	146	SEBASTIAO SALGADO	22
FRANS LANTING	148	AUGUST SANDER	22
JH. LARTIGUE	152	CINDY SHERMAN	22
O. WINSTON LINK	156	STEPHEN SHORE	23:
STEVE McCURRY	160	W. EUGENE SMITH	23
MARY ELLEN MARK	164	ALFRED STIEGLITZ	240
JAMES NACHTWEY	170	PAUL STRAND	24
HELMUT NEWTON	174	THOMAS STRUTH	24
NORMAN PARKINSON	178	HIROSHI SUGIMOTO	250
GORDON PARKS	184	WOLFGANG TILLMANS	251
MARTIN PARR	186	SHOMEI TOMATSU	25
RANKIN	190	JEFF WALL	250
EU REED	194	WEEGEE	260
MARC RIBOUD	200	MADAME YEVONDE	26
HERB RITTS	204	PICTURE CREDITS	270
ALEXANDER RODCHENKO	208		

FOREWORD

This book tells the story of photography in the twentieth and twenty-first centuries through the lives and work of some of the medium's innovators and pioneers. It is a logical starting point for a history. The lives of great men and women help illuminate a long and complex chronology. But in the field of photography, biography is surprisingly under-used. The contributions of great photographers who advanced and shaped the medium have too often been neglected.

Many photographic histories concentrate on technical innovations. The twentieth century saw a parade of inventions - portable cameras, flexible film, the motor drive - that revolutionized what could be shot and how. But an art form isn't defined by its tools. The most innovative photographers put the new inventions to uses no camera manufacturer or optical engineer could have imagined. Photographers as different as Cartier-Bresson and Kertesz, for example, both embraced the 35mm camera when it was still new. But they used the invention to pursue very different subjects that reflect their own sensibilities and concerns.

Some histories attempt to organize photography by subject matter. These tend to outline developments in portraiture or landscape photography or photojournalism as a series of tidy family trees, with successive generations of photographers passing their influence to those who followed in their footsteps. The problem arises when you try to categorize a Renaissance man like Gordon Parks. Photographers Richard Avedon and Irving Penn (whose work, sadly, could not be shown here) made names for themselves shooting fashion, but also turned their talents as portraitists to serious documentary work. The pioneering photographers showcased in this book may have learned from master artists who preceded them, but eventually all broke free from the past to create a body of work uniquely their own.

Unconstrained by chronology or categorization, a reader turning the pages of Masters of Photography can move between artists, decades and genres, making comparisons and noting similarities. You will no doubt find some familiar and beloved images here. You may come across an image you've known for years and, thanks to the biographical texts, learn for the first time the name of the photographer who created it. We all carry a vast visual library of images engraved in our heads: the news photo that scared us as a child, the portrait of a favourite pop star we tore out of a magazine, or the ad campaign that inspired a recent shopping

trip. But few of us know who created these indelible images. It's a curious phenomenon: photographs overshadow their photographers.

Why are so many of the most powerful images of the last century remembered as anonymous icons? The fault may lie in the way these images were made and used. Most of the photos reproduced here were shot commercially, which means they were commissioned by a team of clients, art directors and editors. As the most successful of these images demonstrate, the demands of the marketplace and fussy clients can sometimes inspire the greatest ingenuity and invention on the part of the photographer. Unfortunately, few ad campaigns run photo credits, and a photographer's contribution to the collaborative process is often overlooked.

Perhaps what makes images so universally appealing is also what pushes their creators out of the limelight. As Reuel Golden notes in his Introduction, the explosion of mass media in the last 100 years has given photographs unlimited reach. A photo can be disseminated around the globe and immediately understood in any language. Once published, it can be endlessly reused, endlessly re-examined, endlessly interpreted. The photo carries on a life of

its own long after the recorded moment has passed and the photographer has moved on to other assignments.

In his pithy and pungent text, Reuel Golden places the photos collected here in context, describing how, when and why they were made. More importantly, he never lets us forget that each masterpiece is the product of one artist's creativity and effort. Over the century, these artists' techniques changed dramatically, but their desire for self-expression did not.

At the beginning of the twenty-first century, new digital tools have given us a glimpse of the revolutions still to come in how images are captured and viewed. But no matter how fast and fluent these future tools may be, have no doubt that a century from now there will still be frustrated, self-doubting and anxious photographers struggling to put into images what they cannot express in any other medium. And there will still be a public awed by images too powerful to forget.

HOLLY STUART HUGHES

INTRODUCTION

At this very moment, someone somewhere is taking a picture. Photography may not have been invented in the twentieth century, but it is in the last 100 years that it has become the most common method for men and women to record their experiences and preserve their memories. It is a popular art form - although that is not to say that every photograph is a work of art - but unlike composing a piece of music, or painting in oils, it is relatively straightforward and accessible. Yet its popularity has also meant that photography has had to struggle to gain public recognition as an art form in its own right. Moreover, the fact that photographs can be reproduced has clouded the issue of their value for too long, but at the beginning of the twentyfirst century these prejudices began to be cast aside. There are photographs featured in this book that can be seen hanging side by side with paintings in the world's great galleries, and some of them sell for hundreds of thousands of dollars. From its invention in the 1830s until the latter half of the nineteenth century, the role of photography was more to record, rather than interpret. Still lives, landscapes and portraits were seen as documents of an existing world and the photographer was assigned the task of making these

recordings as accessible as possible. It was a new visual language, but the first wave of photographers wanted it to be easily understood. By the beginning of the twentieth century, they had higher aspirations. They began to see themselves predominantly as artists and pictures were now produced for aesthetic effect, as well as for the purposes of documentation. Cameras had become a tool for self expression, with the same power to move the viewer as paint on a canvas. These pictorialists, as they became known, wanted to set themselves apart from commercial and amateur photographers, which they did by holding exhibitions and setting up magazines dedicated to their work. The irony is that the aesthetic quality of the photograph was judged by how closely it resembled a painting. So with all this new technology at their fingertips, these photographers were using it to replicate a more traditional art form. By the 1920s, the potential of photography was starting at last to be fully realized. The First World War had left an indelible mark on society and its artists. Writers, painters and photographers were less willing to accept the prevailing status quo and in their search for order and meaning in

a chaotic world, they felt compelled to experiment. Photography was no longer just recording, but also challenging and confronting society. It joined forces with other leading art movements of the day, such as surrealism and constructivism, and on an equal footing; it was no longer seen as a poor relation to painting or anything also

anything else. New technology also played its part in photography's acceptance, particularly the Leica camera. The invention of this small, hand-held camera, the first to use 35mm film, meant that pictures could be taken in sequence, quickly and spontaneously. The camera could imitate the movement of the human eye and pictures could be taken at odd angles and from particular viewpoints. Previously, pictures were taken on bulky and unwieldy cameras, using large glass plates and long exposure times, usually under very controlled circumstances. Once photography was able to free itself from these constraints, it was inevitable that the medium would evolve. Nowhere was this evolution more apparent than in the field of photojournalism and reportage. As noted, since their invention photographs had been used as documents of record, for example Roger Fenton's documentation of

the Crimean War in the 1850s, or Lewis Hine's pioneering work on child labour in the early part of the twentieth century; but it was the combination of the invention of the Leica and the development of new printing processes that really propelled the genre forward.

The turning point was the invention in 1910 of a rotary printing cylinder, capable of marrying text with pictures. This led to a cottage industry of photoled magazines that was to thrive until the mid-1950s. Film and paper quality also vastly improved between the two world wars and thus pin sharp images could be achieved, even with pictures taken under difficult circumstances and in poor lighting conditions. Photo-led magazines such as Picture Post and Life gave rise to the picture story, where the photojournalist was given the space and artistic freedom to cover a story in depth and where 'real' people became participants in a human drama, be it war, the Depression or something more mundane, such as a day in the life of a coal miner. Reportage, documentary photography

Reportage, documentary photography or photojournalism are really different ways of describing picture-taking for the purposes of news gathering, with photographs being used as evidence of how we live. The photographer is

the bystander, the observer who is the world's eyes. The century's most famous photojournalist, Henri Cartier-Bresson, talked about photography in terms of capturing the 'decisive moment', and it is these moments that define a century. They can be truly appalling, such as George Rodger's images of the liberation of the Nazi concentration camps, or they can delight, as in the case of Henri Lartique or Robert Doisneau. Photography's greatest gift and ally has been reportage and thus inevitably it is this genre that dominates twentieth and twenty-first century photography. The genre has not stood still: the role of the photographer has progressed from being an objective bystander to presenting a more subjective view. Here pictures go beyond being mere records and take on the mantle of intense personal statements of how the photographer feels about the human condition. These images cannot be separated from the person who took them. Still photographs, whatever the imagemaker's standpoint, have the power to encapsulate often very complex issues in single, iconic images in a way that no other medium comes close to matching. In the first part of the twentieth century newspapers were the only visual newsbroadcasting medium, and people learnt

in their papers. Yet even in these days of twenty-four-hour TV news channels and the Internet, it is the still photographs that people remember above everything else. Documentary photography overlaps with portraiture (the other genre that has dominated in recent times) - yet whereas the former is a record of society, portraiture is more about the individual and how they respond to the promptings of the photographer in a controlled situation. It is not, however, always so clear cut. Is Dorothea Lange's picture of the Migrant Mother, taken during the Great Depression a 'news' picture or a 'portrait'? The best portraits are ones that go beyond face value and tell the viewer something about the sitter's character the picture as an X-ray of the soul. The twentieth and twenty-first centuries are as much defined by individuals as events and this picture by Lange reveals much about the woman and her circumstances. Looking at the wider picture, it also symbolizes the 1930s Depression. Eras are also epitomized by pictures of the rich and famous, the powerful and the beautiful. Celebrity portraiture has been around since the beginning, but it was in the twentieth century, and

about the world by looking at the pictures

in particular after the Second World War, that the currency of fame became truly international and all-embracing. Photography, far from being usurped by movies, TV and music, has been given a new lease of life by the emergence of mass popular culture. Pictures of stars help to sell magazines and papers and certain photographers, entrusted with promoting the right image for the celebrity, have got very rich as a result. Others have made money by capturing the star in an unavarded moment or in a situation that they cannot control, and then selling the pictures to the highest bidder. This is otherwise known as paparazzi photography and it is still very much thriving, fed by our unabating appetite for celebrity gossip.

Fashion falls within this sphere of popular culture: people are defined as much by the clothes they wear as the music they listen to, or the films they go and see. It is remarkable how many of the century's true masters are primarily fashion photographers, for instance Horst P. Horst and Helmut Newton. Newton's often controversial and sexually charged work for Vogue and other fashion magazines gained him the reputation as one of the most influential photographers of the twentieth century, and elevated fashion

photography into new realms of art. Looking ahead to the future, we can dream that when it comes to selecting the key images of the latter part of the twenty-first century, there will be no need for the pictures of war, famine, hardship and poverty that feature all too prominently in this anthology. This unfortunately has been the story of the twentieth century and the early part of this century, of history in fact, but this is the first era in which it has been recorded in such detail. Let us just hope that future generations look at the evidence – these photographs – and learn something.

BERENICE ABBOTT

BORN Springfield, Ohio, USA, 1898 DIED Maine, USA, 1991 DOCUMENTARY AND PORTRAIT PHOTOGRAPHER

The value of Abbott's work was obscured for much of her career by the important role she played in promoting that of Eugène Atget. Her famous portraits of him were made just before his death. Assistant to Man Ray in Paris 1923-25, she worked as a portrait photographer there until returning to New York in 1930. During the 1930s she produced a monumental and detailed record of New York City, which seems directly inspired by Atget's photographs of Paris. Her later work, from about 1939. concentrated on scientific subjects, but she also invented several photographic devices.

KEY BOOK Changing New York (1939)

A gifted portraitist and documentary photographer, Abbott made two great contributions to photography. The first came about through her association with Man Ray and the bohemian cultural

world of Paris in the 1920s In 1925 she was introduced by Ray to the work of Eugène Atget, an unknown but intriguing photographer, then still working in Paris. Her three portraits of him (1927) are the only records of this enigmatic figure apart from an early snapshot. At his death shortly after this sitting, she acquired virtually all that remained of Ataet's archive: 1,500 negatives and 8,000 prints. She devoted much of the next forty years to conserving this work, and promoting its wider understanding. The clarity of vision that she saw in Atget's photography, its direct and effective grasp of the texture of reality informed her own work. On her return to New York in the 1930s she devoted herself to photographing New York in large format, with the same care and attention to detail that Ataet had lavished on Paris. Her work was supported by the Federal Arts Program. and published as Changing New York in 1939. Abbott believed that photography was 'a new vision of life, a profoundly realistic and objective view of the external world'. She was against manipulation of image or subject and what she called the 'superpictorialism' of elite art photographers such as Steichen, Stieglitz and Strand. It seems hardly surprising that her work lacked their support, but her concern with 'straight' photography led her to make interesting and important contributions to scientific photography.

Under the El at the Battery, New York (1936)
This is part of Abbott's famous and monumental series
'Changing New York', in which she photographed the
city in large format. The vibrancy, architecture and street
life of the Big Apple has rarely been better photographed
this century. Note how she perfectly captures the shafts of
light coming through the harsh metal.

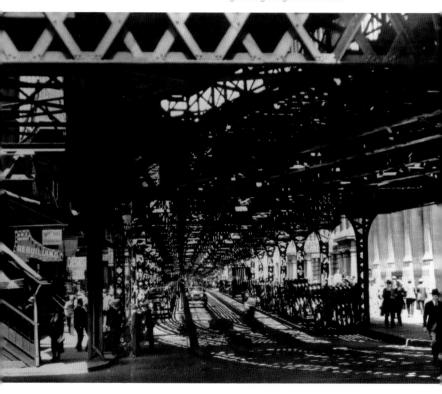

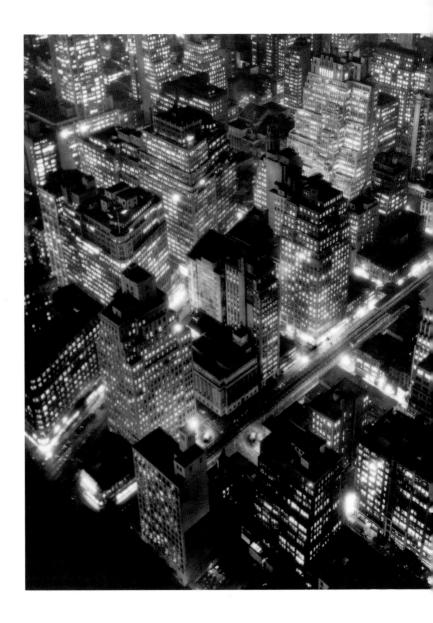

[Left] Night View, New York (1932)

The picture is as much a homage to progress as it is to the city itself. By the 1930s the United States was the most powerful country on earth and these soaring skyscrapers are the perfect metaphor for its vast wealth. The Manhattan skyline has never looked so alluring.

[Below] James Joyce (1928)

This is one of the most famous portraits of one of the century's great writers. Joyce looks quite a dandy with his tie, jewellery, walking stick and hat tilled at a rakish angle, yet there is also something quite sad about his expression.

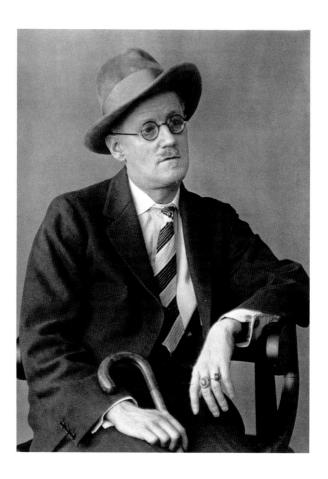

ANSEL ADAMS

BORN San Francisco, USA, 1902 DIED Carmel, California 1984 LANDSCAPE PHOTOGRAPHER

America's greatest landscape photographer. Originally trained as a pianist, but took his first photographs during a vacation to Yosemite Park, which started his lifelong association with the American outdoors. In 1930, met Paul Strand which aroused his interest in 'pure', photography, and in 1931 help found the highly influential 'Group f/64'. In 1941, created the famous zone system, an aid for determining correct exposure and development times. Also helped to start the Photography Department at the Museum of Modern Art in New York and the Department of Photography at the California School of Fine Art. Work is still highly sought after.

KEY BOOK Ansel Adams: Images, 1923-74 (1974)

The United States is a big country and Ansel Adams is the big man with a big camera who captured its full beauty and magnificence, in colour and black and white, for well over fifty years. Adams was part of the 'Group f/64' that took its name from one of the smallest apertures available on a large-format camera. Adams used it, resulting in very clear images with a depth of field. It was, however, more than just a technique. By cultivating a purer response to an environment Adams produced straight pictures, faithful reproductions of what he saw around him, that went against the more 'pictorial' style of the 1920s. Adams was also a man of many parts. He was fascinated with the scientific side of the medium and acted as a consultant to Polaroid for over thirty years. Moreover he invented the Zone System. Yet he was also a romantic artist in the best nineteenthcentury tradition, with a strong sense of adventure who was intrigued and seduced by the natural world. His pictures are a homage to the parks, canyons, deserts, wild terrain and snowy hilltops of the American West and South West, with their vast landscapes and imposing skies. He also favoured close ups of flowers, rocks, thistles and driftwood; the small fragments that help define the natural world. In Adams's photographs, the American landscape is beautiful, mysterious, but never threatening. The rugged, uninhabited parks and canyons are Adams's nirvana that we too can reach through these images. A true pioneer.

Canyon de Chelly National Monument, Arizona (1942)
The Colorado River snakes through the canyon. To take
these sort of landscape pictures the photographer not only
needs to have a good eye, but also to be in robust
physical health. To reach this vantage point Adams would
have been carrying a heavy, large-format camera and a
tripod over rough terrain and in hot weather.

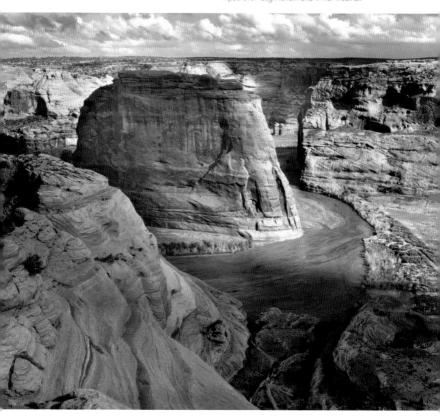

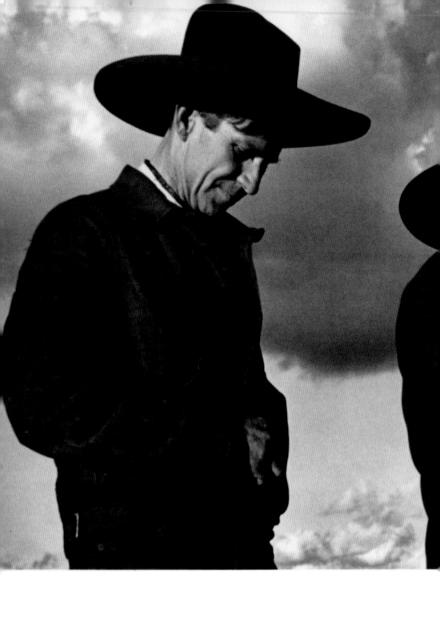

Georgia O'Keeffe and Orville Cox at Canyon de Chelly National Monument, Arizona (1937)

These two were great friends and influences on Adams. He is generally not renowned for his portraits, but he has perfectly captured O' Keeffe's amused expression. Inevitably the two are depicted against a backdrop of the sky.

EVE ARNOLD

BORN Philadelphia, USA, 1913 DIED London, UK, 2012 PHOTOJOURNALIST

Made her name with her sensitive and sympathetic photo essays and celebrity profiles for Life and Look magazines that led to her becoming the first woman to join the world-famous Magnum agency in 1951. Arnold is best known for her work with Marilyn Monroe, but she also has a long and distinguished career as a alobe-trotting photojournalist visiting China, the former Soviet Union, Egypt, South Africa and Afghanistan. A pioneering and formidable photographer who has received countless honours, including Master Photographer from the International Centre of Photography (ICP) in New York. She is an integral part of the photography scene in Britain - her adopted home since 1961.

KEY BOOKS In China (1980) and Flashback: the 50s (1978)

Eve Arnold's roll call of sitters reads like the history of the twentieth century. Step forward please Joe McCarthy, Malcolm X, Margaret Thatcher, Queen Elizabeth, Indira Gandhi Eisenhower, Clark Gable, Ioan Crawford and of course Marilyn Monroe. Her images of the fading starlet, taken on the set of The Misfits in 1961, turned Arnold from a highly respected photographer into a figure of world renown. In front of Arnold, Monroe was prepared to drop all pretence of glamour and reveal almost painfully what she had become: a fragile woman in emotional and physical decline. Yet with Arnold there is never a sense of her exploiting her subjects; she has a remarkable ability to put them at ease and is highly protective of them both during and after the shoot. This gentle approach was at odds with some of her Magnum colleagues who were more intent on going for the jugular, but Arnold correctly maintained that she still got the pictures. On assignment, Arnold adopts a low-key approach, relying on minimal equipment, little fuss and, by and large, ambient light with the images often printed guite darkly. She relies more on instinct, quiet observation and developing a relationship with her sitters, no matter how fleeting. For Arnold, photography has never been about grand sweeping statements, but rather moments of introspection that can be equally profound. She is often cited as a great female photojournalist, a label that has irritated her and with reason. Arnold is one of the greats, full stop.

Marilyn Monroe (1960)

The actress is resting between takes during a photographic studio session in Hollywood during the making of the film *The Misfits*. Monroe trusted Arnold perhaps more than any other photographer and she repaid that trust by somehow managing always to make Monroe look very beautiful, but also very human at the same time. The direct eye contact is also irresistible.

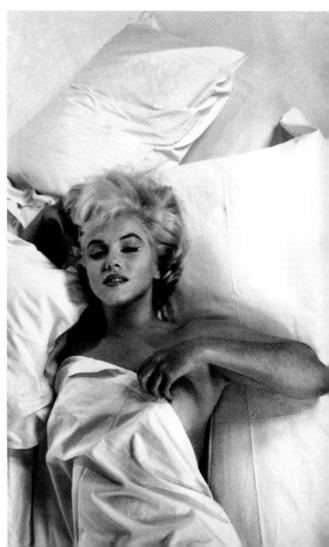

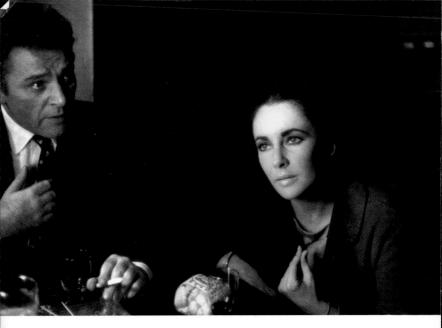

[Above] Elizabeth Taylor and Richard Burton (1963) This was taken during filming of *Becket* at Shepperton Studios, London. Taylor and Burton were at the time the most famous couple in the world, although their relationship was tempestuous and often married by heavy drinking. Arnold captures all this, as well as their obvious beauty.

[Right] Jacqueline Kennedy arranging flowers with her daughter Caroline.

From a series of portraits of President's Wives, taken in 1961. The informality of the pose and the natural and instinctive interaction between the subjects is typical of Arnold's relaxed style of portraiture.

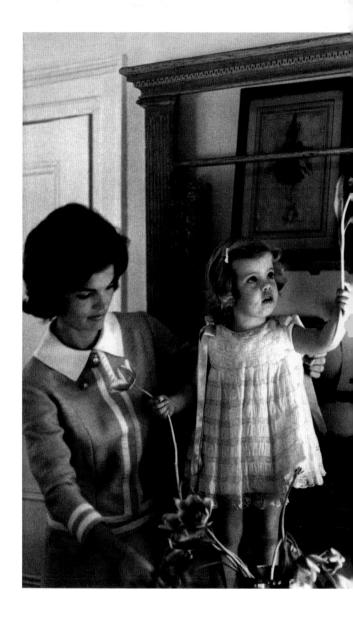

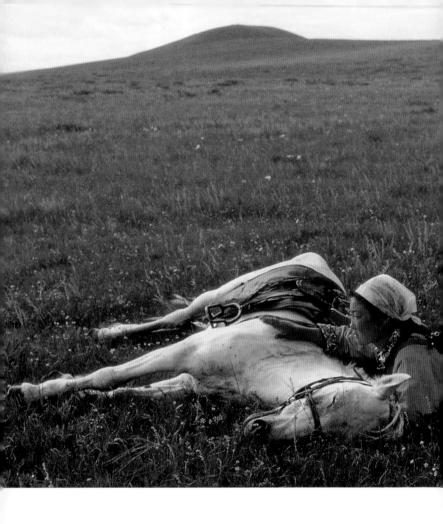

Horse Training for the Militia in Inner Mongolia (1979) When Arnold took this series of pictures she was well into her sixties, but her compositional and narrative skills were as strong as they had ever been. Although she is most closely associated with her pictures of Marilyn Monroe, Arnold was a relentless world traveller:

EUGÈNE ATGET

BORN Libourne, France, 1857 DIED Paris, France, 1927 DOCUMENTARY PHOTOGRAPHER

Despite the importance accorded to his work, Atget remains a shadowy figure. Orphaned at the age of four he was brought up by an uncle. After a brief career as a sailor, Atget took up acting without great success before finally establishing himself in Paris, first as a painter then, from about 1890, as a photographer, using a technique that never varied. He advertised his 'documents for artists' from 1892, and in 1898 began to make his famous views of Paris. In 1899, he settled in Montparnasse where he spent the rest of his life, and died in poverty.

KEY BOOK Atget Paris (1992)

Atget was known to many painters (for instance, Derain, Matisse, Braque and Picasso bought pictures from him) and this might explain his discovery as a 'naïve genius' by the Surrealists in the 1920s.

Otherwise it is possible his work would have died with him, for the deceptively simple documentary pictures he made of the sights and people of the Paris of the late nineteenth and early twentieth centuries were considered little more than functional illustrations. Yet Man Ray, André Breton and Pierre Mac Orlan saw something new in these robust and direct photographs, made on 18 x 24 cm $(7 \times 9\frac{1}{2})$ in) glass plates using a wooden bellows camera with a simple rapid rectilinear lens. They found images which suggested that a hidden world of the unconscious lay beneath the surface of the city. Atget created many series, some on streets and shops, some on historic monuments and statues, some on parks and flowers, others on street traders and vehicles: there are even some nude studies. The simplicity and limitations of his technique, which led him to photograph in the early morning when there were few passers-by, gave a certain empty and surreal charm to his cityscapes. Atget sold his albumen contact prints to museums, galleries, collectors and painters, and they still turn up from time to time. In 1926 he met Berenice Abbot, who conserved many of his negatives, and helped to keep his reputation alive. Immediately after his death, Modernist photography embraced his work, and it was widely appreciated as art rather than 'mere' documentation.

Le Quai, I'lle de la Cité (1925)
Atget prefered to photograph in the early morning when there were no passers-by, which gave the city a somewhat haunted and mystical feel. The Seine has always been a photographer's favoured subject.

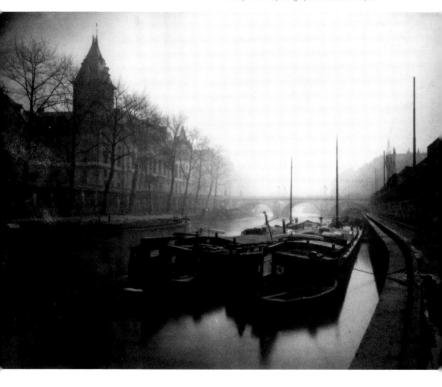

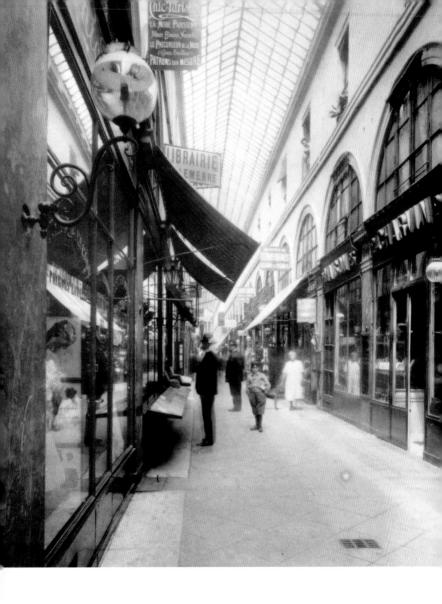

[Left] Passage de Choiseul, Paris (1907) The shopping arcades of Paris are monuments to good taste and style and they remain unchanged to this day. [Below] Omnibus la Vilette-Saint Sulpice (c. 1900) Atget was however not averse to photographing the hustle and bustle of the city if the occasion demanded it.

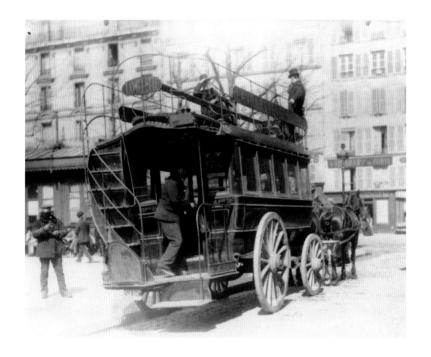

CECIL BEATON

BORN London, UK, 1904 DIED Salisbury, Wiltshire, UK 1980 FASHION AND PORTRAIT PHOTOGRAPHER

Born into a comfortable upper middleclass family, Beaton was educated at Harrow and Cambridge (1922-25). Self-taught, he picked up the camera for the first time as a young boy to make pictures of his family and friends, and by 1925 he had a flourishing studio. Visiting New York in 1930, he began a long partnership with Condé Nast, under exclusive contract to Voque throughout the decade. He began working in Hollywood in 1931, and when he returned to London was made official photographer to the Royal Family. During the Second World War he photographed for the Ministry of Information. Returning to fashion photography in 1945, he adopted the new realism, but eventually left Vogue for work in theatre and cinema. Knighted in 1972, he suffered a stroke in 1974 which curtailed his career until 1979, when he briefly took up the camera again.

KEY BOOKS Persona Grata (1953) and Cecil Beaton (1982)

From the beginning, Beaton's work was romantic and staged. He had a fascination with set design, and even as a youth would construct elaborate tableaux in which his sitters figured as if they were statues. It is not surprising, then, that he combined twin careers in photography and set design, and his sets and costumes for the films Gigi and My Fair Lady won Oscars in the 1950s. As a photographer. Beaton's work of the 1920s and 1930s combined both a backward look to the Edwardian era of high society and a pictorialist style, and was mostly made in large format. Surrealist elements begin to intrude in the 1930s (particularly in his Hollywood portraits), but his work remained effete, snobbish and mannered until 1940, when commissions for the Ministry of Information took him to blitzed London and several theatres of war. Beaton then discovered a new realism with the Rolleiflex camera, using natural light and a simple, stark approach. Portraits of generals and politicians such as Churchill sit easily alongside pictures of ordinary people, and his image of an injured child in a London hospital (right) is credited with gaining American sympathy for the British cause. Beaton increasinally employed a similar style in his post-war fashion photography. As official photographer to the British Royal Family, Beaton's status as the leading photographer of his era was only seriously challenged in the early 1960s, when newer approaches emerged which seemed more in tune with the times. He responded by making a series of looser and less formal portraits of celebrities, and despite ill-health, remained active until his death.

Bomb Victim (1940)

The wide staring eyes of four-year-old Eileen Dunne greet the photographer as she sits in her bed at the Hospital for Sick Children in London. Although best known as a portrait and fashion photographer, Beaton worked for the British Government's Ministry of Information during the War.

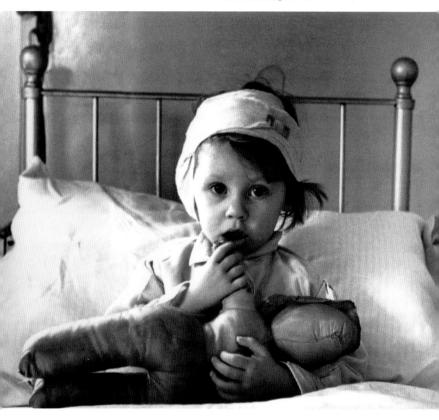

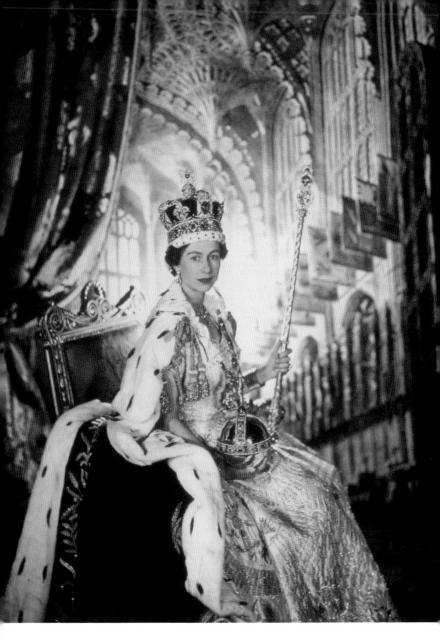

[Left] Elizabeth II's Coronation (1953)

Beaton here is trying to emphasize the tradition of the Royal Family and its role in the heritage of Britain, while at the same time making the new Queen as glamorous as a Hollywood film star. A difficult balancing act, but one that he just manages to pull off.

[Below] Audrey Hepburn (1964)

This is a publicity still from the film My Fair Lady, for which Beaton won Oscars for costume and set design. Hepburn looks suitably radiant; at the time the picture was taken she was one of the most famous women in the world.

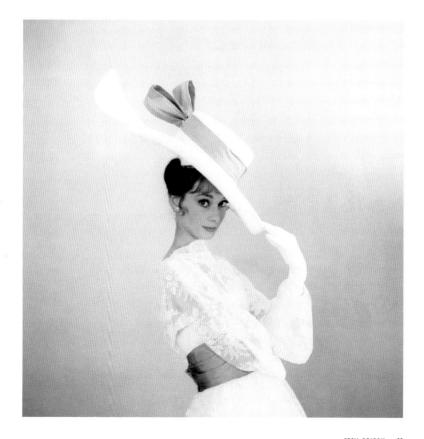

BERND AND HILLA BECHER

Bernhard 'Bernd' Becher BORN Siegen, Germany, 1931 DIED Rostock, Germany, 2007 Hilla Becher, nee Wobeser BORN Berlin, Germany, 1934 FINE-ART PHOTOGRAPHERS

After meeting in the Düsseldorf Art Academy as students, the Bechers began their photographic collaboration in 1959 and were married two years later. Their images were first exhibited in Siegen in 1963, and in 2004 they were jointly awarded the Hasselblad Foundation Award.

KEY BOOK Typologies (2004)

The industrial buildings obsessively documented by the Bechers over the course of their 50-year career are rusting and abandoned. There are no workers here, no signs of life. This is a world in decline; the Bechers own world, since they lived and worked in the heartland of German industry, but also the West in general. As Bernd said, 'I became aware that these buildings were a kind of nomadic architecture which had a comparatively short life... It seemed important to keep them in some way.' Adopting a pseudo-scientific mode

of display they called 'typologies', the Bechers arranged multiple images of one type of building in grids on the gallery wall. By offering a comparative catalogue of building types, they show the enormous variety within a tradition – and therefore the surprising degree of individuality and creativity exhibited by each exemplar (an early show was titled 'Anonymous Sculptures'). This paradoxical strategy, both de-individualizing and individualizing building at the same time, relates their typological grids to contemporary conceptual art, such as Ed Ruscha's famous 1966 book Every Building on the Sunset Strip. The ambiguous position of their images – in between documentary and high art - did not seem to bother them. 'The question,' they said, 'if this is a work of art or not is not very interesting for us.' Their slippery approach has been enormously influential: teaching for decades at the Düsseldorf Academy where they first met, their students include such giants of contemporary photography as Thomas Struth, Andreas Gursky, and Candida Höfer. These representatives of the 'Düsseldorf School' - with their large-scale, high-impact, colour-saturated images - may seem far removed from the conceptualism of their teachers. However, their use of large format cameras producing highly detailed shots; their repetitive series; and their interest in formal patterns reflecting social structures, are all squarely within the Becher tradition.

Water Towers (1980) Similar yet dissimilar, water towers become 'anonymous

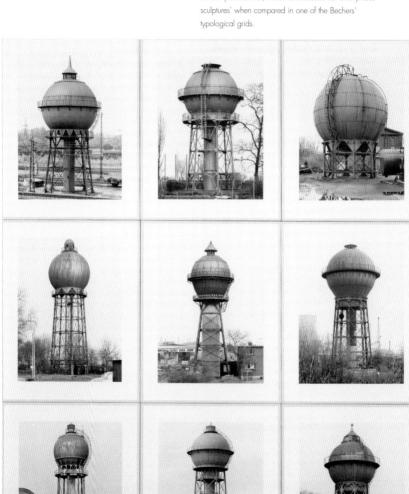

MARGARET BOURKE-WHITE

BORN New York, USA, 1904 **DIED** Stanford, Connecticut, USA, 1971

PHOTOJOURNALIST

Studied at Columbia and Michigan Universities, 1921-23, taking course at Clarence White School of Photography, After failed marriage, 1924-26, returned to Cornell University and decided to take up photography. Her early industrial and portrait work in Cleveland impressed Henry Luce, who appointed her chief photographer at Fortune in 1929, and later at Life magazine (for which she made the first cover photograph in 1936). Became the leading photojournalist of her era, working in all parts of the world and in most of the wars of the period up to 1957, when she abandoned her career after contracting Parkinson's disease.

KEY BOOK Margaret Bourke-White: Photographer, Sean Callahan (1998)

Photojournalism itself is barely a century old, and for all practical purposes it only got going in the 1920s. The career of

Margaret Bourke-White began to take off almost precisely at the moment when new, mass-circulation, illustrated magazines started to appear. A well-educated young woman, she decided to become 'rich and famous' at the age of twenty-three. That it might be possible to do so through photography argues for the potential of the medium in a period of economic and social upheaval. After founding a highly successful studio in Cleveland to make dramatic, machine-age, industrial photographs, she was taken up two years later by press magnate Henry Luce to create a strong photographic style for his new business magazine, Fortune. Her stock in trade was a form of modernism, strongly composed but visually simplistic, and was a popular element of the Life idiom, which placed great store on showing the world to America. This included Soviet Russia and pre-Nazi Germany in the early 1930s, but also involved well-publicized work on the problems of depression-era America itself, in her notable collaboration with the writer Erskine Caldwell. 'You Have Seen their Faces' (1937), Bourke-White carried out many corporate assignments which undermined her reputation as a socially concerned photographer, but her 1937 image of poor black people in a bread-line, in front of a poster showing an affluent white family under the slogan 'there is no way like the American way' remains a timeless statement about the fundamental inequalities of American society.

Twenty-Four Hour Worker, USSR (1930)

Always a socially concerned photographer, Bourke-White

embraced the idea of showing the rest of the world to America. When this picture was taken, the USSR was still something of an unknown quantity. It is a simple portrait but rather effective.

BILL BRANDT

BORN Hamburg, Germany, 1904 DIED London, UK, 1983 DOCUMENTARY, PORTRAIT AND FINE-ART PHOTOGRAPHER

Often described as one of Britain's most important photographers although born in Germany, and didn't arrive in the UK until the early 1930s. Prior to that, had assisted Man Ray in the 1920s and travelled in Spain and Hungary. From 1938, his work appeared regularly in Picture Post and Lilliput, two highly influential magazines that specialized in photo essays. In the 1940s, moved away from photojournalism and took more abstract pictures of landscapes and nudes, as well as portraits of writers and artists. After falling into relative obscurity in the 1950s and 1960s, re-established himself in the 1970s as an art photographer.

KEY BOOKS Bill Brandt Photographs 1928–1983 (1993)

Throughout his life, Brandt wanted to be thought of as an enigma. This had as much to do with his desire to suppress his German origins as his uncommunicative

nature. It is as if his mysterious personality mirrored the London fog of his pictures. There is indeed something enigmatic about Brandt's professional life, as it is particularly hard to classify. His early career as a photojournalist is not without controversy. Many of his photo essays were planned meticulously and were set-up shots - common practice at the time - but his skill was in making them look as natural as possible. Brandt even employed friends and family to act as models in his photos, but he was always reluctant to admit to the constructed nature of some of his key pictures. From here, Brandt moved towards photographing melancholy and uninhabited landscapes and cityscapes around the United Kingdom. There is a coldness about these pictures but also a haunting beauty. These attributes were taken to even greater extremes in his nudes - his biggest legacy. There are touches of surrealism in these pictures; there is also both an obsession and slight distaste for human flesh. It is never established whether the women resent or welcome the camera which all adds to the sense of unease. 'Perspective of Nudes' (1961) baffled the critics when it first came out; women had rarely been portrayed in such stark architectural terms, but its influence can still be seen today in fashion, portrait and commercial photography. A challenging and highly versatile image creator.

Two women wearing the latest in sunbathing fashion (1948)

[Left] Underwear Fashion (1949)

The woman is modelling the latest fashion in nylon underwear at least on the surface, but on a deeper level the picture has elements of fetishism and voyeurism, with the girl being an unwitting participant in Brandt's personal drama.

[Below] Roadside Graves (1945)

Darkness and all of a sudden a churchyard is illuminated by the headlights of a passing car. The effect is quite eerie but then again it is meant to unnerve the viewer, a response Brandt was often seeking in his work.

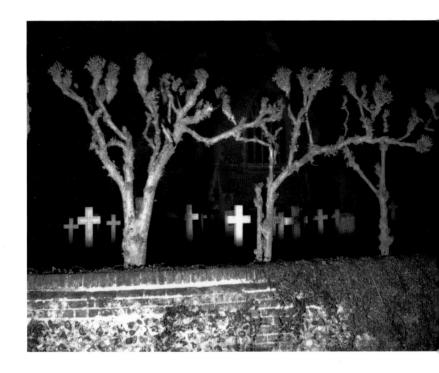

ROBERT CAPA

BORN (Andre Friedmann), Budapest, Hungary, 1913 DIED Thai-Binh, Vietnam, 1954 PHOTOJOURNALIST

The most famous war photographer of the century whose violent death was somehow inevitable, considering the nature of his work. Originally studied science at the University of Berlin between 1931 and 1933. Self tauaht. he started as a photo lab assistant and then set himself up as a freelance photographer after moving to Paris. Made his name with his pictures of the Spanish Civil War (his picture 'Loyalist Militiaman at the Moment of Death' is still discussed to this day). Covered the Second World War (most memorably the D-Day landings), China, the Middle East, and finally and fatally, Vietnam. Was also one of Maanum's founders and an accomplished portrait photographer.

Robert Capa was the prototype for the hard-living, hard-drinking war photographer, addicted to danger, who lived life on the edge. He was also a

person who revelled in his own myth and knew that his vocation had a certain glamour that would attract the attention of hangers-on and beautiful women. Yet what he photographed was far from glamorous: it was suffering, misery and chaos on a terrible scale. His career coincided with some of the most bloody decades in history and Capa was always there on the front line, an evewitness for the folks back home. Capa's pictures are very much grab-and-run affairs that have become powerful icons for an appalling period in twentieth-century history. Think of the Spanish Civil War and the one image that remains indelible on the mind is the falling Loyalist soldier. Ironically, for a man who had a reputation of cutting through the artifice and telling it straight, that picture is still dismissed by some, to this day, as a 'set-up', carefully orchestrated by Capa. This has somewhat tarnished his reputation, but added to the mystique as well. Capa was also a fine peace-time photographer: he took some remarkable portraits of actors and artists; and also took a perverse pleasure in documenting the opulent and decadent lives of Europe's upper classes. His other lasting legacy is the creation of the prestigious Magnum agency that developed an ethic and aesthetic for photojournalism that is still shaping the way we see the world today.

Loyalist Militiaman at the Moment of Death (1936)
One of the most famous photographs of the twentieth century, but also one of the most disputed. Is it a set-up?
Was the man actually shot? To this day people are still uncertain. Either way it does not really matter, as this image will always be the perfect metaphor for the anonymity and impersonality of war.

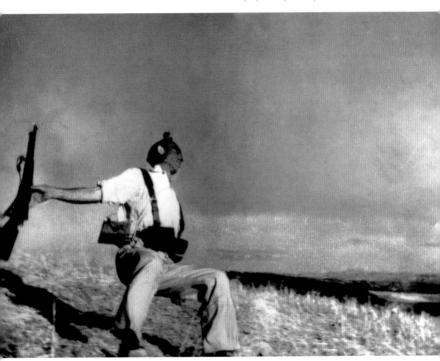

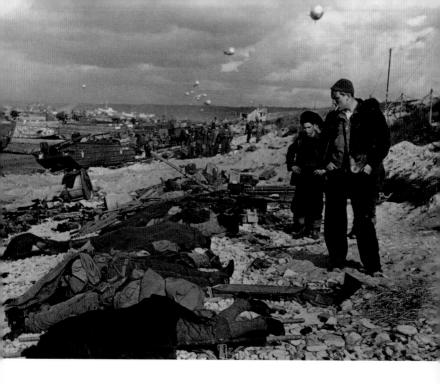

[Left] Normandy Invasion (1944)

Capa was part of a crew which took the commanders and men from the Allied Expeditionary Force in the D-Day invasion on 6 June – this is taken on that dawn morning following the first landings. Capa revelled in being at the centre of the action.

[Below] Pablo Picasso and his son Claude in Golfe Juan (1948)

The most famous painter of the twentieth century, captured by one of its most famous photographers. The men had a great deal of respect for each other and as a result Capa was able to photograph Picasso in a very informal and relaxed manner savouring the joys of fatherhood. The boy's expression is also something to treasure.

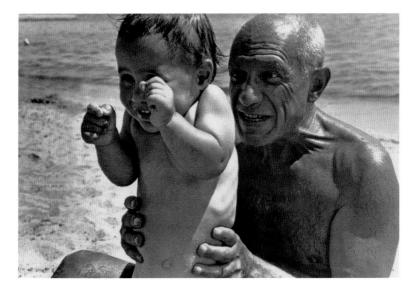

HENRI CARTIER-BRESSON

BORN Chanteloup, France, 1908 DIED Montjustin, France, 2004 PHOTOJOURNALIST

Born into a wealthy and influential French family, Henri Cartier (as he was known until the 1940s), spent much of his youth imbibing Bohemian culture in Paris. Studied painting under André Lhote 1927-8 and frequented the Surrealist circle. Discovering photography while convalescing after a year in Paris, he made the new Leica 35mm camera his chosen tool. His surrealist snapshots made in Europe and Mexico during travels in 1932-35 gained him a reputation as an art-photographer in New York. On his return to France, Cartier took up photojournalism in 1937 after a brief period as assistant director to lean Renoir. Imprisoned during the war, but escaped in time to photograph liberation of Paris in 1944. Co-founder of Magnum Photos agency in 1947, he published the 'bible' of documentary photography, The Decisive Moment in 1953, and was active as a photojournalist throughout the world until the late 1970s. Then devoted himself to painting and drawing.

KEY BOOK Henri Cartier-Bresson: Photographer (1979) Though it is hard to prove the assertion that Henri Cartier-Bresson has been the most influential photographer of the twentieth century, few would disagree that the style of monochrome 'decisive moment' small-camera photography with which he is associated has become all-pervasive. Bestknown today as a photojournalist and portraitist. Cartier-Bresson always wanted his work to be seen in the wider context of art and more particularly painting. Born into one of the richest 200 families in France, the young Cartier-Bresson hovered on the fringe of the surrealist circle in the mid-1920s, before taking a trip to Africa as a hunter. Invalided home with a tropical disease, he took up photography because of frustration with his abilities as a painter. One of the first photographers to exploit the 35mm Leica as a mechanical sketchbook, Cartier-Bresson honed his ability to compose images with a telling precision which cuts straight to the heart of the matter. His early work was consciously surrealist, but by the late 1930s a developing political conscience led him to embrace photojournalism, a trade he later ennobled through the founding of the Magnum agency, and publication of his 'textbook', The Decisive Moment. His approach involves the photographer putting 'one's head, eve, and heart on the same axis', shooting as many pictures as possible until a single image emerges in which all the elements fall into place to symbolize a person, place or event. This philosophy, akin to that of the Zen archer, has inspired countless thousands of imitators, It also gave photojournalism, hitherto considered a minor trade, the status of art.

Pakistan (1948)

Pathan nomads of Afghanistan leave Pakistan before the heat rolls in from the base of the mountains at the Khyber Pass, which they are crossing. This picture has great drama and a sense of history unfolding before the viewer's eyes. It has also a slight visual twist: everyone has their back to the camera, apart from the man at the edge of the frame who is staring straight at the photographer.

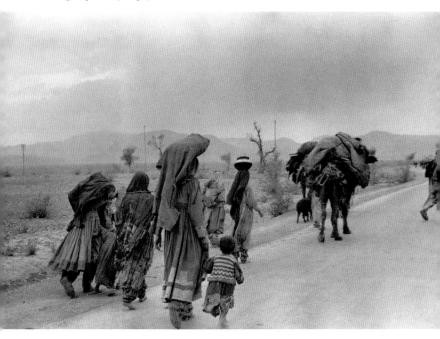

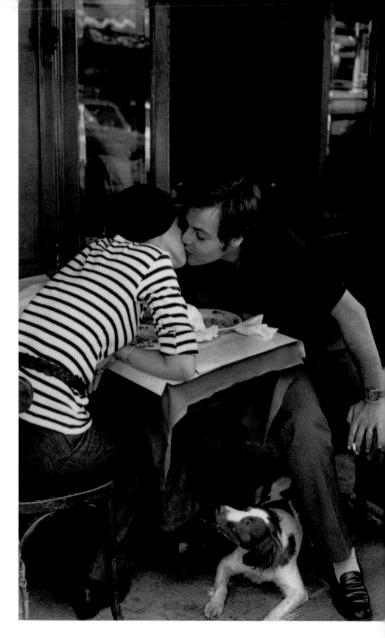

[Left] Paris, Boulevard Diderot (1969)

This shot has all the hallmarks of Cartier-Bresson's ability to compose images with a telling precision which cuts straight to the heart of the matter. The decisive moment is the lover's kiss, but it is made that much more poignant by the mournful eyes of the dog staring at the girl, who may be a possible rival for the man's affections.

[Below] Simone de Beauvoir, Paris (1947)
Generally Cartier-Bresson's portraits are not regarded quite as highly as his reportage photographs, but this picture of a somewhat baleful de Beauvoir is a true classic. The photograph has perfect symmetry and balance between subject and environment, and her mournful expression is perfectly in tune with post-war Paris.

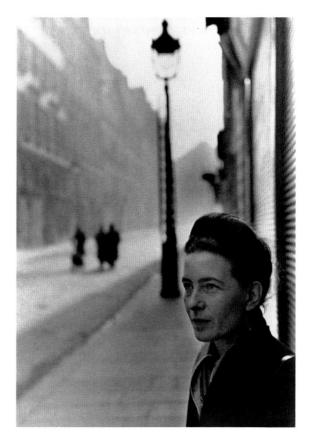

ALVIN LANGDON COBURN

BORN Boston, USA, 1882 DIED Rhos-on-Sea, UK, 1966 LANDSCAPE/PORTRAIT/STILL-LIFE PHOTOGRAPHER

Born into a solid middle-class family. Coburn took up photography at the age of eight. Shortly before moving to London in 1899, his cousin Fred Holland Day introduced him to pictorialism and helped him to exhibit with the Linked Ring Brotherhood. Studied with Steichen and Robert Demachy in Paris, 1901. Opened studio in New York, 1902, and studied with Gertrude Kasebier Returned to London in 1905 and photographed leading artists and writers. From 1907 to 1909 studied gravure printing and opened his own presses to print his books on London and New York. Experimented with autochrome colour photography, and in 1917 invented 'Vorticist' photography. In 1919 he became a freemason, to which he increasingly devoted himself for the rest of his life.

KEY BOOK Alvin Langdon Coburn, Mike Weaver (1986)

George Bernard Shaw thought him the greatest photographer in the world at the age of 24, and Coburn's precocious and prolific talent saw to it that his work impressed a wide audience. Member of the Linked Ring and Photo-Secession movements. he exemplified the rich and aifted amateur of these élitist circles who strove to demarcate his practice from professional photography on the one hand, and mere snapshottery on the other. Coburn's photographs of London and New York exemplify the constantly shifting grandeur of the modern metropolis, and his semi-abstract urban compositions (such as 'The Octopus', 1912) prepare the ground for the plunging views of the New Vision. Like so many of his peers, Coburn was obsessed by symbolism, and wanted his photography to enunciate deeper, mystical and more elusive truths about nature and the human condition. Perhaps this explains his fascination with Japanese art, whose graphic and simplifying influences can be clearly seen in many of the studies for his books on London (1909) and New York (1910). He had special telephoto lenses designed to achieve the same flattening of perspective which can be found in a Hokusai woodblock print. Later studies of the Grand Canyon and Yosemite (1911) seem to transcribe Japanese values in landscape art to American subjects. A deepening concern with spiritual values can be seen in Coburn's mature work, and when pictorialism became moribund, his attempts to create a new cubist photography around 1917 seemed destined to fail. Embracing freemasonry, he abandoned art for religion in 1924, and thereafter made few photographs.

Ezra Pound (1917)

The poet and Coburn collaborated on this Vorticist portrait which involves a triangular arrangement of mirrors over the camera's lens which gives a geometrically distorted photograph. By the time these abstract images were exhibited in 1917, the iconoclastic edge of Vorticism had been blunted by the First World War.

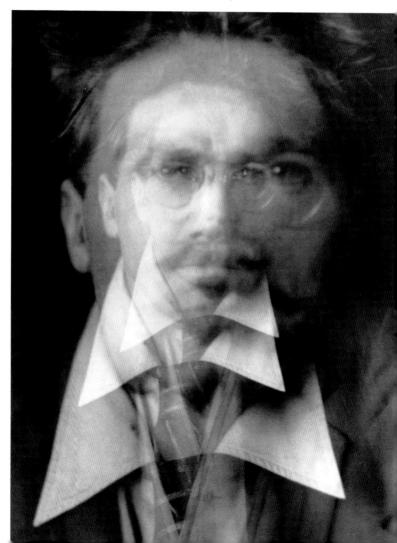

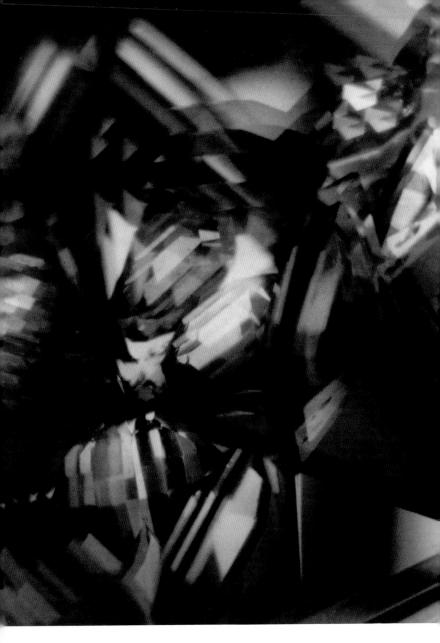

[Left] Vortograph (1917)

One of Langdon Coburn's more abstract images. By today's standards this attempt at creating a new type of photography and way of seeing the world appears somewhat hamfisted, but they are still not without interest.

[Below] Flat Iron Building (1905)

Coburn was obsessed with Japanese art and many of his landscapes were kept very simple and graphic and were also quite melancholic.

IMOGEN CUNNINGHAM

BORN Portland, Oregon, USA, 1883 DIED San Francisco, USA, 1976 PORTRAIT AND FINE-ART PHOTOGRAPHER

University-educated in America and Germany (where she studied photochemistry), Cunningham took up photography as a hobby before devoting herself to the medium. Trained with Edward S. Curtis in 1907-9, and opened a portrait studio in Seattle in 1910. After marriage and children interrupted her career, she took up modernist 'straight' photography in 1921 after settling in California, making carefully observed studies of flowers and the body. Weston selected her work for the important Stuttgart Film und Foto exhibition of the 'new vision' in 1929. Supporting herself with portrait and commercial work, Cunningham's long career saw her achieve an important place in American photography.

KEY BOOK Imogen Cunningham: Flora (1996)

Although associated with the Edward Weston circle. Cunningham is far less well known than Weston's mistress. Tina Modotti, vet her work is in most ways more impressive. From early pictorialist photographs (portraits and symbolist tableaux) to her distinctively organic nudes and botanical studies, Cunningham's work has a guiet and precise guthority. Early symbolist portraits of the Seattle literary-artistic circle gave way to an intriguing fascination with natural forms. Her large-format nudes ('Nude', 1932) recall flowers, and her botanical subjects often display a sensuality which was rediscovered in the flower studies of Robert Mapplethorpe. Cunningham's are generally the better photographs, because there is an artist's appreciation of the interplay of form and function, combined with a botanist's understanding of growth and fertility. In such works as her studies of Calla lilies in the mid-1920s, Cunningham displays the technical mastery which marks her photography, with the ability to explore the natural form in new and exciting ways. If she had been a man, Cunningham might have been better known: but then her sensibility would have been markedly different.

Rondal and Padraic (1932)

Cunningham is intrigued by the natural form in all its shapes and guises and throughout her career she alternated between taking pictures of people, such as this unconventional portrait, and carefully observed studies of plants and flowers.

[Left] Alba (late 1920s)

What is particularly intriguing about this picture is how the hair falls over the woman's face in such a way that her features are disquised to make her look plantlike.

[Below] Calla with Leaf (c. 1930)

The flower here is imbued with a delicate sensuality and displays Cunningham's appreciation of the interplay between form and function. Cunningham's pictures now sell for hundreds of thousands of dollars at auction.

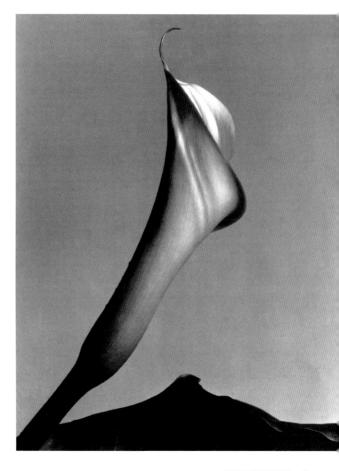

EDWARD S. CURTIS

BORN White Water, Wisconsin, USA, 1868 DIED Los Angeles, USA, 1962 DOCUMENTARY PHOTOGRAPHER

Grew up in Minnesota, close to the Chippewa and Winnebago Indian tribes. Curtis, who was self taught in photography, spent thirty years methodically photographing the faces, lifestyles and remnants of the cultural traditions of native American tribes throughout the USA, many of whom had already been confined to reservations. The cost of this venture and the production of the resulting limited edition volumes was a staggering 1.5 million dollars. Only about 270 sets were completed and sold. Curtis's exhaustive project lay relatively unseen until a highprofile show in 1972 at the Philadelphia Museum of Art

KEY WORK The North American Indian (1972)

Travelling by wagon, Edward Curtis exposed his first glass plates of native American Indians in 1895, at a point in time when their fate had already been

sadly decreed. Curtis's self-appointed task, to place on record what was left of the vanishing tribes through photographs and detailed explanatory text, is one of the world's great photographic documents. Some three decades and 40,000 negatives later, Curtis considered this work complete. During that time he photographed scores of tribes including the Sioux, Apache and Navajo, paying his subjects a dollar a time from a sack full of silver coins. Curtis records the tribes grinding medicines, hunting ducks or simply looking proud on horseback by their painted tepees. Here are glimpses of an ancient world now lost to us. By 1906, the project had almost bankrupted Curtis, but he was fortunate to secure massive financial backing from the powerful banker J. Pierpont Morgan; an ironic gesture given that Morgan was a major beneficiary from the modernization of the USA. The resulting book, The North American Indian, is a staggering record in which some of the great chiefs - Mosquito Hawk, Old Eagle and Red Cloud - draw on what self respect they have left in the face of the white man's victory. Curtis consciously strives through composition and style to present and preserve his subjects as 'noble warriors'. Despite the monumental nature of this project, and its continuing historical significance, Curtis, inexplicably, has been largely overlooked by the chroniclers of the history of photography.

Hopi Girl and Mother (1900)

In one of the most remarkable photographic records of the twentieth century, Curtis documented the Native American Indians' traditional way of life and offered glimpses of an ancient world now lost to us.

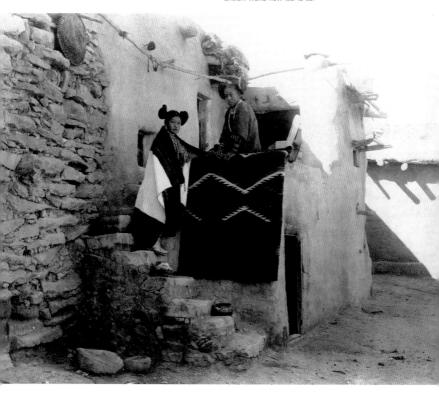

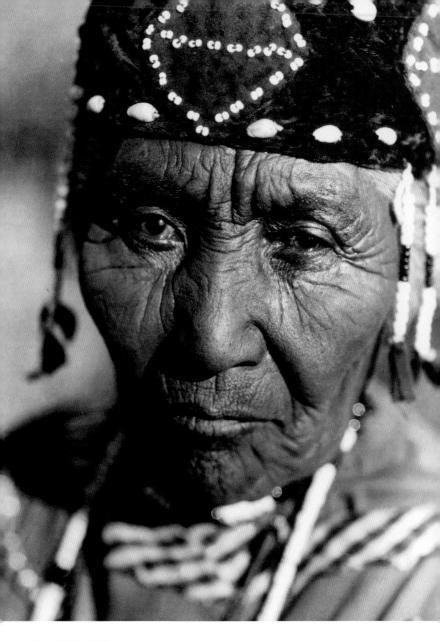

[Left] Wife of Madoc Henry (c.1923)

A very powerful portrait of a woman whose turbulent past and uncertain future is etched across her heavily lined and wrinkled face. Age may have withered her

somewhat, but her spirit shows no sign of breaking.

[Below] Lakota Sioux Mother (date unknown)

Curtis consciously, through style and composition, presents his subjects as 'noble warriors'. This picture has a touching simplicity and it is interesting that the mother is photographed turning away slightly from the camera while her child is staring straight at Curtis.

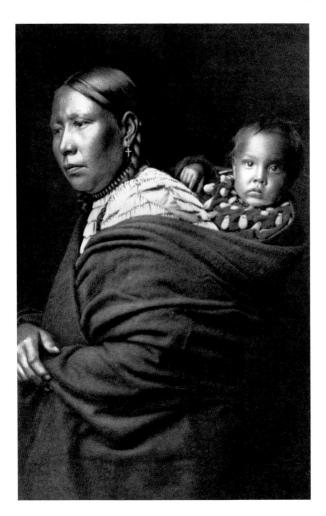

ROBERT DOISNEAU

BORN Gentilly, France, 1912 DIED Paris, France, 1993 PHOTOJOURNALIST

France's favourite photographer, more popular even than Cartier-Bresson in his native country. He originally trained as a lettering artist in the 1920s. In 1931 he becomes assistant to André Vianeau. modernist photographer and sculptor and acquires his first Rolleiflex camera and takes pictures of Paris. Was also an industrial and advertising photographer for Renault. During the War joined the French Resistance and photographed liberation of Paris, Post war was a portrait and fashion photographer for Voque and up until his death freelanced for many national and international magazines.

KEY BOOK Robert Doisneau: A Photographer's Life (1995)

In French, his name rhymes with that of the urban sparrow. Like the birds, he fed on the scraps picked up in the streets of Paris, the 'city of light'. The best-known photographer in France, Doisneau's work has been likened to a national photograph album, for he was a deft and amusing

observer of the minor aspects of life and culture which define Frenchness, Closer acquaintance with his photographs reveals a fundamentally subversive, even anarchic. character who mocks authority and denigrates establishment values. Doisneau's work is one of the most impressive achievements of humanistic reportage, of those who took their hand-held cameras out on the streets to record the lives of ordinary people for the new illustrated press from the early 1930s to the 1950s. When he died he left behind more than 325 000 negatives, the majority made within Paris and its suburbs, for he rarely ventured with his camera beyond the confines of his own country. Doisneau's finest work bridges the divide between documentation and art. A great innovator, he devised new methods for creating intriguing and subversive images, such as the distorted Eiffel Tower, His ideas were formed through acquaintance with those who dominated French culture from the 1930s. to the 1960s. Whether photographing a humble concièrge or a great painter like Picasso, Doisneau managed to combine the ideas of modernism and surrealism with a narrative thrust that made his photographs immediately arresting. Some are constructed tableaux – such as the world-renowned 'Baiser de l'Hôtel de Ville' (1950) – but most were the result of long hours spent on a street corner, waiting 'for chance to work its magic'.

Les Chiens de la Chapelle (1953)
The streets of Paris are very much Doisneau's metier. The strength of this picture lies in its use of shadow, its linear construction and of course the dogs being quietly observed by the two bystanders in the background.

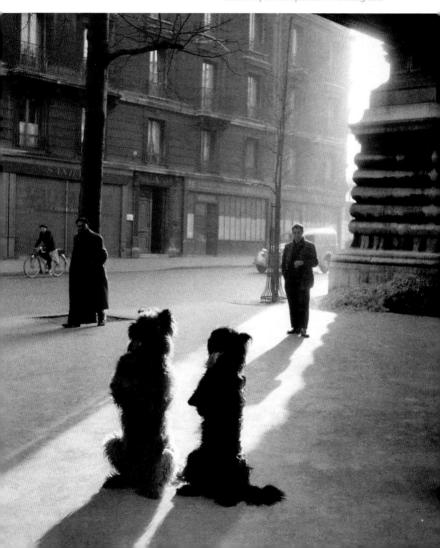

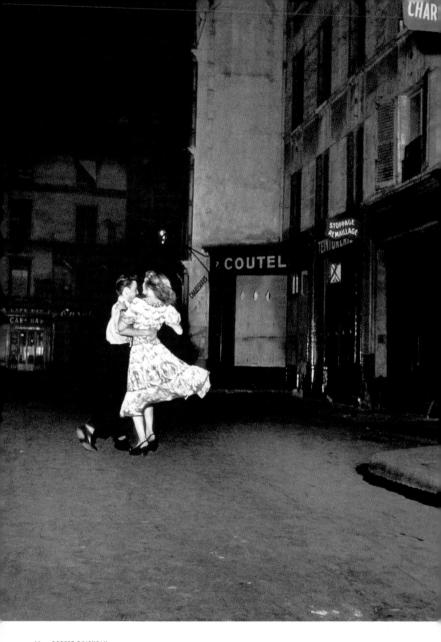

[Left] La Dernière Valse (1949)

Otherwise known as the last waltz. Paris has always had a reputation as a romantic city and the myth has certainly been perpetuated by photographers such as Doisneau.

[Below] Câfé Noir et Blanc (1948)

As well as the streets of Paris, Doisneau was also irresistibly attracted to its câfés and drinking establishments. The title of the picture is a pun on the idea of black or white coffee, but also refers to the woman's dazzling dress, which contrasts with the more drab attire of the men.

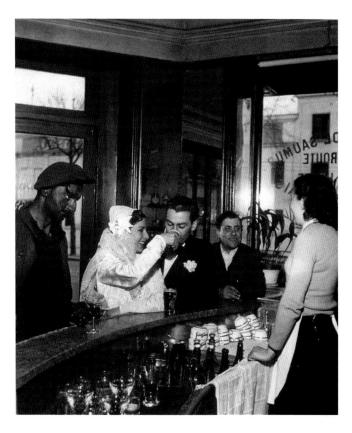

TONY DUFFY

BORN London, UK, 1937 SPORTS PHOTOGRAPHER

Duffy gave up his career as a chartered accountant to concentrate on his hobby, sports photography, after taking a picture, while a tourist at the 1968 Mexico Olympics, of Bob Beamon's world-record breaking long jump. Went on to form Allsport, the world's most famous sports picture agency which now has branches in many countries. His innovative work included such works as Sport and the Body (1973), which featured naked sports stars. Duffy has won numerous international awards including International Sports Picture of the Year in 1975, 1977 and 1981. In 1983, moved to Los Angeles to set up Allsport Photography, USA.

If Tony Duffy hadn't been at the Mexico Olympics, present at the exact moment that Bob Beamon broke the long-jump record, Allsport, the world's biggest sports picture agency, would never have got off the ground and no doubt Duffy would

have continued his career in accountancy. These days, sport is a huge global phenomenon worth billions of dollars and every event, no matter how minor, is endlessly photographed and televised by professionals paid good salaries to make sure that they never miss anything. Back in the late 1960s, sport was a more lowkey affair and an amateur, although an obviously very accomplished one such as Duffy, could not only get a good vantage point but could also photograph one of the key moments in sporting history under the noses of professionals. It was an extraordinary leap and Duffy dramatically captures Beamon in full flight, arms and legs akimbo, pushing himself towards a place in the record books ... and immortality. Allied to Duffy's photographic skills was his business acumen: a background in accountancy certainly helped to launch his new career, and he had the good sense to syndicate the picture all over the world but make sure that he kept the rights. From this modest beginning Allsport has continued to grow, and at the last Olympics in Atlanta, it was the official agency for the International Olympics Committee. There is no doubt that 1968 saw a big leap for Beamon, but it started an even bigger one for sports photography.

Whoops! Skate boarder (late 1970s)
Duffy was one of the first photographers to see the potential of skateboarding and he witnessed its growth first-hand on the west coast of America during the 1970s.
A classic action shot.

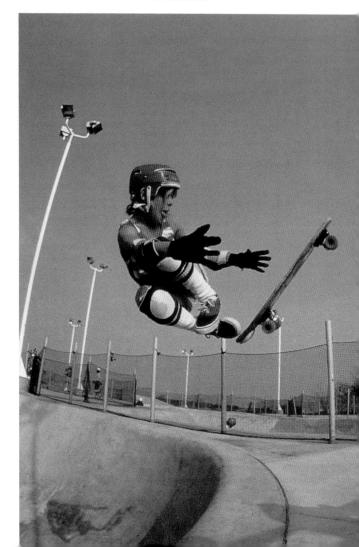

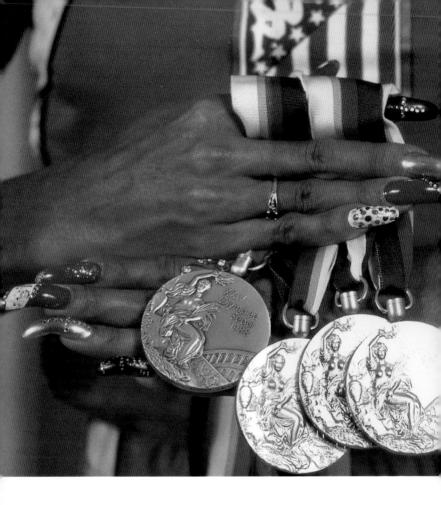

Florence Griffith Joyner (1988)

One of the most photogenic and controversial sports stars of the 1980s, who passed away in 1998. She was equally well known for the length of her fingernails as for her achievements in track and field.

WILLIAM EGGLESTON

BORN Memphis, Tennessee, USA, 1939 **FINE-ART PHOTOGRAPHER**

Born to a well-to-do Southern family, Eggleston attended a series of universities, never completing a degree but picking up photography when a friend gave him a Leica. Inspired by Cartier-Bresson's book The Decisive Moment, Eggleston began taking blackand-white pictures of his surroundings, but it is his colour work that truly changed photography. In 1967 he took some of these early colour transparencies to John Szarkowski, curator of photography at MoMA, and in 1976 he was the first artist to have a solo show of colour prints at that institution. Since then he has been exhibited in countless group and solo shows around the world, and in 2004 he received the Getty Images Lifetime Achievement Award. A documentary about his life and work titled William Eggleston in the Real World was released in 2005.

KEY BOOK William Eggleston's Guide (1976)

A brown bitch, her face vacant as only a dog's face can be, laps at a brown puddle. The scene is banal, even slightly disgusting, but the image seems to be urgently trying to convey something. Is it something about brownness? About seeina? About consumerism? About the object and our relationship to it? Eggleston's work, with its emphasis on the apparently inconsequential, tends to raise these paradoxically profound questions. When they were first exhibited in 1976, his super-saturated colour prints (created using an expensive dye-transfer process previously reserved for high-end advertising) exploded in the face of a stuffy photography world that insisted on the documentary verité of black and white. Ansel Adams wrote a letter of complaint to MoMA about the show, and the critics hated it. Equally disconcerting was Eggleston's focus on the banal, which aficionados of the 'decisive moment' thought boring and meaningless. In images like the famous 'red ceilina' there is no action or even any identifiable subject apart from colour. But though the meaning may be obscure, this is certainly not boring, as an ocean of red drips from the wall like wet blood (as Eggleston put it). Equally sinister is his shot of the inside of an oven. Close-cropped, this everyday object with its wire shelves receding into the void might suggest a diagram demonstrating perspective - but it could also be the last view of a suicide. If his resonant palette

Greenwood, Mississippi (1973)
Eggleston's red ceiling is a mystical affirmation of the power of colour on a par with Yves Klein's blue paintings; but its purity is complicated by the inclusion of pornographic images.

and trademark motifs – sauce bottles in diners, kitsch knick-knacks, fast food packaging, roadside signage, American cars – have lost some of their capacity to shock, it is because we all see through Eggleston's lens these days. His enormous impact on photographers like Stephen Shore, Nan Goldin, Wolfgang Tillmans and Martin Parr, but also on directors like Wim Wenders and Gus van Sant, and on

musicians such as Primal Scream who use his images as album sleeves, mean that his 'democratic vision' has seeped into the public consciousness in a way that few other photographers can boast. Meanwhile Eggleston himself remains an elusive figure, affecting the sharp suits of the Southern gentleman but also, as his video diary Stranded in Canton reveals, part of a hard-partying rock and roll subculture.

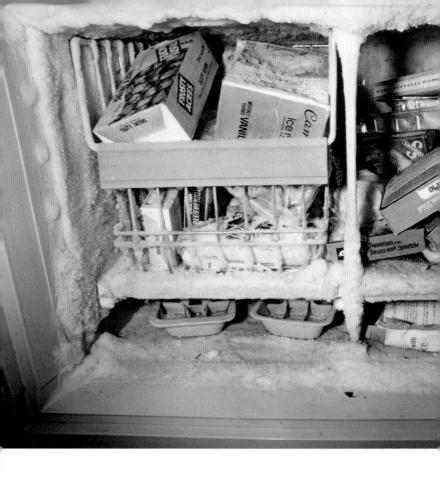

Untitled (c. 1971-3)

Lost in the deep freeze, Eggleston discovers mass cultural artefacts as if they were woolly mammoths emerging from beneath the arctic ice.

ELLIOTT ERWITT

BORN Paris, France, 1928 DOCUMENTARY/COMMERCIAL PHOTOGRAPHER

Born of Russian parents and lived in Europe before emigrating to the USA in 1939. After studying at the LA City College, he began working in a darkroom and then moved to New York in 1948. Turning point was meeting Edward Steichen and Robert Capa and in 1950 worked at Standard Oil as a photographer. In 1954 joined Magnum and has become one of their most high profile and prolific photographers. Winner of countless awards, Erwitt has had one-man exhibitions all over the world, made films and published many books.

KEY BOOKS Son of Bitch (1974), On the Beach (1991) and Between the Sexes (1994)

Elliott Erwitt has a gently mocking and probing eye that has always preferred to look at society's absurdities rather than its ills. He is extremely serious about his

photography, yet conversely has always advocated the importance of humour in his pictures. As he says: 'Making people laugh is one of the highest achievements you can have. It's difficult: that's what I like about it.' Dogs play an important part in his pictures, although he claims there is no fascination with them, he just likes taking photographs of them because they 'don't complain, don't make you sign releases and don't bother you'. The doas in his pictures are not just cute animals, but creatures which have the ability to emote and react like humans. They have distinct personalities and many of the images illustrate their interaction with mankind and their role in society. The dogs are symbols of a more gentle world; a world that is a long way from the harsh reality seen through the eyes of many of his Magnum colleagues. Erwitt's vision has always been a subtle one. In his images a glance between a man and a woman may appear on first viewing insignificant, but on closer examination the whole relationship between the two can unravel right before your eyes. He has a light touch, and some of the work may appear inconsequential, but his acute perceptions of the everyday and mundane are as valid as any pictures of war or famine. Any photographer who can effortlessly raise a smile should be cherished

The funeral of President John F. Kennedy at Arlington, Virginia in November 1963, featuring his widow Jacqueline and his brother Robert, who was also to fall victim to a political assassination five years after this picture was taken.

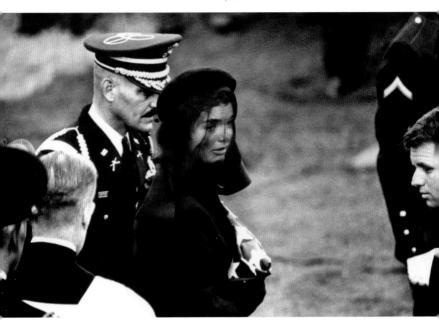

New York City (1974)

These dog portraits reveal an uncanny resemblance between hound and human personalities. 'Essentially they are pictures of people, but I would get into trouble if I took pictures of people doing some of these things," says Erwitt.

ROBERT FRANK

BORN Zurich, Switzerland, 1928 SOCIAL DOCUMENTARY. **FASHION AND FINE-ART** PHOTOGRAPHER

In 1947 Frank emigrated from Switzerland to America. There he got a job working for Harper's Bazaar, and in 1950 curator Edward Steichen included his work in the landmark MoMA show '51 American Photographers'. In 1955 he won a Guagenheim Foundation Grant and used the money to travel America, producing the work that would make him most famous. In 1961 he had his first solo show at the Chicago Art Institute, and in 1996 he received the Hasselblad Foundation Award

KEY BOOK The Americans (1959)

Swiss photographer Robert Frank drove across the weird terrain of postwar America recording its endless flags and cars, and its dispossessed, unconventional and xenophobic inhabitants (Frank was briefly imprisoned in Arkansas, essentially for speaking with a foreign accent). Exposing the underbelly of the conservative

1950s, Frank shone a light on bikers, black transvestites, seareaated buses and teenage delinquents, as well as on the upper classes, represented by gurning TV stars, bloated politicians, ranting demagagues, and wizened fur-wrapped New York royalty. In the course of his journey he shot around 27,000 frames. and then over the next year whittled these down to just 83 images. Published as The Americans in 1959, critical reaction was hostile. The photographic establishment, used to the pin-sharp definition of the prevailing style (exemplified by Ansel Adams' grandiose landscapes), complained of Frank's 'meaningless blur, grain, muddy exposures, drunken horizons and general sloppiness', but younger Americans understood. In fact the book's introduction was supplied by that avatar of young America, Jack Kerouac, who wrote 'To Robert Frank I now give this message: You got eyes'. A generation agreed, but by the time the book was published. Frank - tired of his bread-and-butter commercial work - had 'retired' from photography and moved into film. Frank's first film, the underground classic Pull Mv Daisv (1959). featured Allen Ginsberg, narration by Kerouac, and a deliriously stoned plot. In 1971 Frank went into exile, moving to an old fisherman's shack in Nova Scotia with his second wife. There, beset by terrible family tragedies, he has returned to photography, capturing the bitter seasons of the frozen north.

Political Rally – Chicago [1956]
Echoes of Magritte abound in this surreal image, where the head of a musician is transformed into his instrument.
The juxtaposition of the flag suggests an element of critique,

LEE FRIEDLANDER

BORN Aberdeen, Washington, USA. 1934

DOCUMENTARY/FINE-ART PHOTOGRAPHER

A street photographer whose approach was greatly influenced at its outset by the work of Robert Frank, Lee Friedlander has made his career since the mid-1950s from the uncertainties of American life, its transient, ephemeral and ironic qualities. Like his contemporaries Garry Winogrand, Danny Lyon and Diane Arbus, his work represents an important stream in American photography of the 1960s and 1970s, in which the act of travelling and photographing intensively became essential to the photographer's own sense of identity. Friedlander works by the patient assembly of bodies of photographs on themes that emerge years later. These include projects on American monuments, trees and the female nude

KEY BOOK Nudes (1991)

Friedlander has made the new social landscapes of modern America his preferred subject matter. Opting to work in an unobtrusive manner, he observes the routine and ordinary events that define the American condition. The alienated vision of the nation, which marks the appearance of Robert Frank's The Americans in 1959, set the scene for a style of photography which emphasized personal reactions to everyday life, rather than the consensual and narrative vision of the 1930s. Friedlander exhibited his images, which often dealt with seemingly meaningless reflections of a passer-by in a shop-front, or the ways pigeons fly around civilwar statues, with the similarly alienated visions of American life of Winogrand and Arbus at the Museum of Modern Art, New York in 1967. The exhibition was titled 'New Documents', and emphasized that documentary photography could be elusive and artful, rather than concerned with wider social messages. Friedlander uses a small hand-held camera to make pictures which seem little more than snapshots, but which capture events such as social gatherings, or features of the natural landscape such as trees and flowers, in a way which makes their visual qualities apparent despite their unpromising or unattractive nature. It is the essentially meaningless and fragmentary nature of contemporary life that forms his subject matter.

Newark, New Jersey (1962)

A marvellous snapshot of Americana and its obvious symbol of the burger bar . The manager is balefully looking out into the street wondering where the business is going to come from, and we share his anxiety.

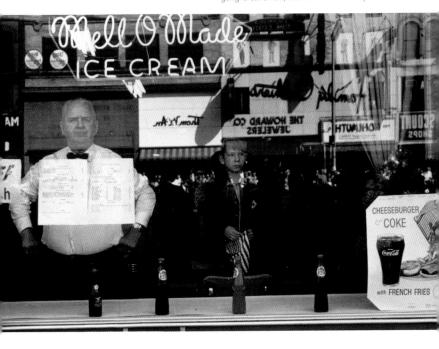

[Left] New Orleans (1968)

Friedlander has always been drawn to the mundane and the commonplace. America for him is not a country of vast canyons and endless highways, but little scenes of people interacting in the streets and in the stores. It is very much a personal vision.

[Below] New Orleans (1968)

Friedlander has always been attracted to shop signs and logos – the universal language of consumption in the United States. There is a visual joke occurring in this picture, with Friedlander wanting us to believe that the showcar belonging to the diner is about to go in pursuit of the cars on the street.

FAY GODWIN

BORN Berlin, Germany, 1931 DIED Hastings, UK, 2005 LANDSCAPE PHOTOGRAPHER

After a cosmopolitan childhood and youth spent in many parts of the world due to the travels of her diplomat father and actress mother, Fay Godwin settled in London in 1958, and started to take photographs of her children in 1966. Family circumstances led to her becoming a freelance photographer from 1970, specializing initially in portraits of writers and artists. Commissioned to produce a walkers' handbook on the Ridgeway in 1975, she found her true metier in landscape, recorded mainly in black and white and most often in medium and occasionally large format. An active campaigner for countryside access, she was president of the Ramblers Association from 1987 to 1990

KEY BOOK Our Forbidden Land (1990)

There is a radical edge to Godwin's best landscape photography. She is a committed walker, who began this activity as recreation in the 1950s, but later

practised it professionally with a camera, as a means of documenting issues about ownership and control of the natural heritage of Britain. From the earliest publications of her work in guidebooks, it has concentrated on the traces of human intervention which give landscape its form and variety, which may include litter, desecration, industry or exploitation. Working in a precise and detailed way in black and white she uses the contrast of the material to make images of great depth and clarity. They are rarely if ever about the beauty or lyricism of a place, for she prefers to focus on the raw and stark features which make it distinctive. Through collaborations with writers of a similar persuasion (the poet Ted Hughes and the novelist John Fowles). Godwin's photography developed a hard and unremitting realism, which does not shrink from juxtaposing modern signs and ancient standing stones, which takes the land as it is, rather than how it may appear to more romantic observers. Particularly evident in her work are the margins between land and sea, town and country, industry and agriculture; it is starkest in her recording of the myriad ways in which 'our' land is forbidden to us by private, corporate and state landowners alike. In recent years she has begun to work on a different type of subject matter (often flowers or garden scenes), frequently small scale, usually in close-up but most significantly in colour.

Untitled from Hawaii Secret Lives Series (1994)
In recent years Godwin has zoomed in on the flowers
and plants that make up the countryside. They are
particularly gentle pictures that concentrate on form
and shape.

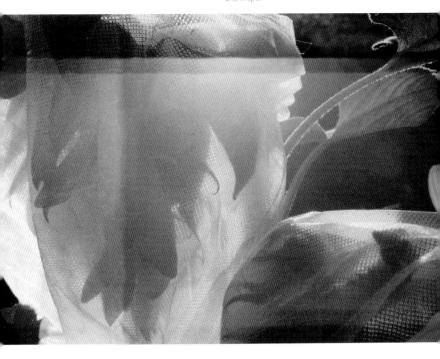

[Left] Chatsworth House, Derbyshire (1988)
Godwin prefers to focus on the raw and stark features of a place which make it distinctive and are her photographs rarely about the beauty or lyricism of a given scene.

[Below] The Needles, Isle of Wight (1987/8)
Godwin is so much more than a landscape
photographer and even when depicting something as
obviously picturesque as this, the viewer is looking
below the surface to find out what her pictures tell us
about the natural world.

NAN GOLDIN

BORN Washington DC, USA, 1953 FINE-ART/EDITORIAL PHOTOGRAPHER

One of the last decade's most influential photographers, Nan Goldin turned to photography after her sister's suicide as a way of preserving and holding on to the memory of precious times. She moved to New York in 1979 where she started the day-to-day record of her life amongst the free-living community, a community impelled by sexual liberation and drug dependency. Out of this revealing record she has produced the slide show 'Ballad of Sexual Dependency', which includes disturbing images of Goldin's appearance after suffering physical abuse at the hands of her boyfriend; a book The Other Side, an illuminating record of her transsexual friends; and a 25-year retrospective exhibition 'I'll Be Your Mirror', Goldin has exhibited worldwide and received grants from The National Endowment for the Arts and DAAD Berlin

KEY BOOK The Ballad of Sexual Dependency (1987)

Nan Goldin not only lived through the chaos, addiction and euphoric excess of fringe New York during the late 1970s and 80s, but had the ability to document and photograph her own 'scene' spontaneously, with affection and compositional brilliance. There is no sense of any invasion of privacy or exploitation about these pictures, for the people Goldin mirrors are her closest friends and lovers who willingly took part in the construction of an extraordinarily vivid and candid extended 'family album'. This was just one long party, not yet clouded by the spectre of HIV. It's a story with a tragic end, however, as Goldin's pictures turn out to have put on record the unfolding tragedy of heroin abuse and full-blown AIDS. The power of Goldin's work lies in the fact that she never sentimentalizes or appears judgmental about her subjects. Instead, we sense the photographer's close participation and genuine understanding in the unfolding stories. Goldin retains the memory of wanting to be a junkie in her early teens, as a 'way of being as unlike my middle-class upbringing as it was possible to be'. In fact, revolution and liberation are at the core of Goldin's work, and both are particularly underscored in her book The Other Side, a candid but euphoric portraval, before and after surgery, of her transsexual friends who we are invited to see clubbing, with their families, making love or just dressed up to the nines. Ironically, the close-in and raw. snapshot aesthetic of Goldin's pictures has been the catalyst for a wave of heroin chic and commercial fashion photography, a connection from which Goldin is at pains to distance herself.

Jimmy Paulette and Taboo! in the Bathroom, New York County (1991)

This picture is as famous for its subject matter as its closein, raw and snapshot aesthetic, which influenced the new wave of 1990s fashion photographers.

Greer and Robert on the bed, New York City (1982) Goldin is very much part of the world that she photographed and therefore she has unlimited access to her subjects. There is no sense of exploitation even though these people, who are on the margins of society, are often caught off guard in private moments.

ANDREAS GURSKY

BORN Leipzig, Germany, 1955 FINE-ART PHOTOGRAPHER

Europe's pre-eminent photographic artist who specializes in large-format colour photographs of expansive settings, some natural, but mostly man-made. Studied in Essen and Düsseldorf in Germany in the mid-1980s. At the end of the decade his work first came to public and critical attention. He was also a key player in a European movement that wanted photographs to be framed and presented in art galleries and to be regarded as works of art. Has been exhibited all over Europe and North America and in 1998 was awarded the Citibank Private Bank Photography Prize.

KEY BOOK Photographs from 1984 to the Present (1998)

The phrase 'the big picture' could have been invented for Andreas Gursky. His images are huge, majestic studies of vast spaces, painterly in scope and taken with a cold, detached eye. Whether it be a grim factory floor, a multi-storey

housing block in Paris, a crowd of partyaoers at a rave or an atrium in an Atlanta hotel. Gursky meticulously documents these monumental arenas with painstaking detail. They are studies in human behaviour, but it is not explained in any way - just presented as fact. The people are no more than ants as they go about their corporate endeavour or leisure activities. The camera is never close enough for us to get involved in the crowds, or to see them as individuals. We, like Gursky, are simply drawn to the mass of people and the architecture or landscape where they congregate. There is always an interesting dynamic going on between the frenzied and intense activity depicted, and the calm, rather self-conscious way in which the pictures are framed and composed. For example, in the famous studies of the Hong Kong Stock Exchange, Gursky has been compared to a latter-day Brueghel, and there is something quite brutal about both artists and the way they reduce man to his lowest common denominator. Yet brutal is perhaps harsh, as both men are satirists. There is affection, even compassion, but also a suggestion that too many people doing too many things is an isolating and bewildering experience. As the century draws to a close, Gursky is the ultimate outsider looking in at us.

Times Square, New York (1997)
This is a more traditional architectural photograph, with
Gursky drawn to the form and composition of the Square
itself. Taken from such a high angle, New York resembles
a spacecraft.

May Day II (1998)

This in fact is a huge rave and the sheen across the frame of the picture is dry ice. Gursky's pictures have a habit of reducing man to his lowest common denominator, so these dancers look nothing more than ants.

Chicago Board of Trade (1997)

Gursky is attracted to the activities and motion of commerce and capitalism. This is part of an ongoing project on financial institutions. There is an obvious contrast between the frenzied activity and the detached and clinical manner in which it is photographed.

ERNST HAAS

BORN Vienna, Austria, 1921 DIED New York, USA, 1986 PHOTOJOURNALIST AND COMMERCIAL PHOTOGRAPHER

For nearly four decades, Haas's name was synonymous with colour photography, although his earliest photo essays were in black and white, such as the first train returning Austrian prisoners of war in 1950. This was picked up by Life and he soon afterwards joined Magnum. Started his early experiments with colour that bore fruit in a cover and a twenty-four-page spread, also for Life, on New York City in 1953. In 1957, Life published an essay on bullfighters, which marked the beginning of his widely imitated motion studies. Travelled extensively and published many successful books. Advertising work includes Air France, Mobil and Volkswagen.

KEY BOOKS The Creation (1971); In America (1975); Deutschland (1977); Himalayan Pilgrimage (1978)

'What I am after is a hidden structure,' says Ernst Haas of his colour

photographs. '... your eye sees it, of course but you're not allowed to be too conscious of it.' Prior to Haas, colour was very much an unknown quantity in photojournalism, as one of his Magnum colleagues remarked: 'It was certainly new - nobody had done it before, and nobody has stopped doing it since.' For Haas, seeing the world in colour was instinctive: as soon as he arrived in the USA from war-torn Europe at the beginning of the 1950s it became for him the natural way of observing the New World. Haas always wanted to be an artist and says that his pictures were inspired by the free form of Picasso's paintings and hence the reference to the hidden structure. He believed that black and white photography was too flat and that colour, if used effectively, could give a picture an extra dimension. Nowhere is this more apparent than in his seminal pictures of New York where this jaded city takes on a new lease of life as colours swirl around the frame to their own rhythm. To achieve this effect, Haas relied on his unerring compositional sense and two films. Kodachrome 25 or 64, with no filters except an occasional polarizer. This mastery of colour meant that Haas effortlessly moved into the commercial sphere and, by a certain ironic twist, this rugged individualist who went against the grain ended up shooting the Marlboro Man adverts in the 1970s.

Red Rose (1970)

A brilliant still life of swirling, bright and vibrant colour. Haas always maintained that black and white photography was too flat and colour, if used properly, could give a picture an extra dimension.

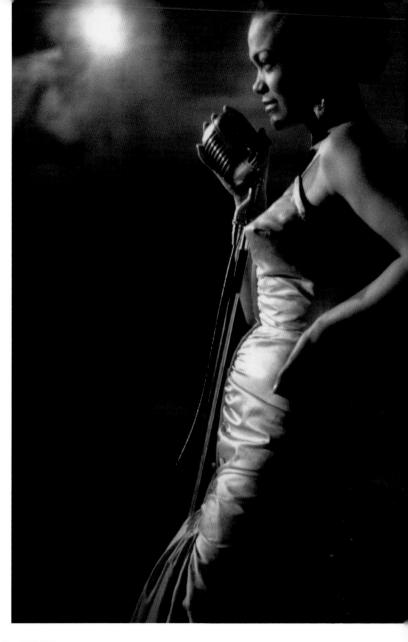

[Left] Eartha Kitt (1952)

Haas brilliantly conveys the sultry singer performing in a New York night-club. Stage shots can often look contrived and stilled but with this live portrait the viewer is virtually transported into the ambience of a smoky night club.

[Below] Golden Light (c. 1985)

A yellow-robed Buddhist monk holds up another robe to the sun at Angkor Wat, an ancient temple complex at Angkor, the old capital of Cambodia. This picture has elegance, mystery but also great subtlety, and all done in colour.

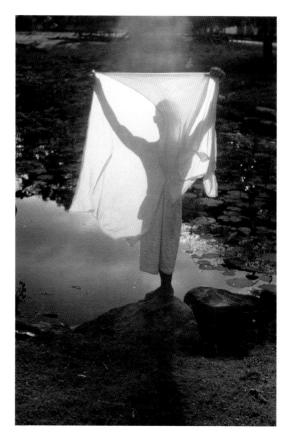

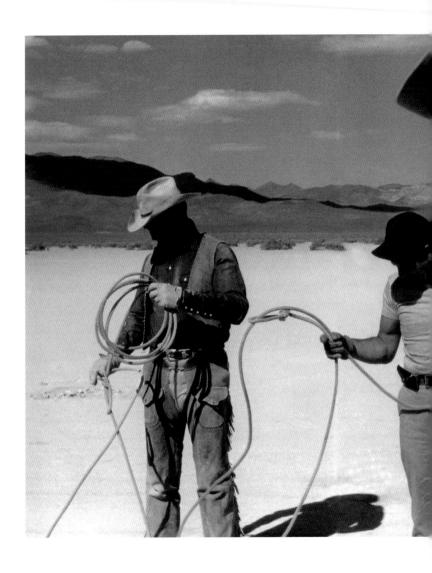

American film actors Clark Gable, Eli Wallach and Montgomery Clift on location in the Nevada Desert during the filming of The Misfits (1960). The picture appears as if it was taken almost off the cuff, as it is framed quite unconventionally, with Clift's hat dominant.

BERT HARDY

BORN London, UK, 1913 DIED limpsfield, uk, 1995 DOCUMENTARY AND ADVERTISING PHOTOGRAPHER

Affectionately regarded as the great cockney storyteller of British photojournalism. After a variety of jobs, joined a news agency in the 1930s as a darkroom assistant and printer. Once he discovered the Leica, he never looked back and soon became associated with Picture Post: the famous British photography magazine, a more low-key version of Life. It was the Second World War, though, that really established his reputation; first photographing the Blitz and then as a sergeant photographer in the army Film and Photographic Unit. After the war, covered many events including the Korean War, but also established an alternative career as a commercial photographer.

KEY BOOK Bert Hardy: My Life (1985)

'I must have the eye, you can't be taught photography,' said Bert Hardy, and he was certainly right on the first count. Like Arthur Eisenstaedt's bond with *Life*, Hardy was very much associated with Picture Post and the golden age of British photojournalism. Picture Post was a photoled magazine which ran candid-camera reports on British life, the classes at work and at play, health and social issues, as well as more hard news features on world events. At one point, Picture Post was selling millions and Hardy was its brightest star. This was at a time when magazines and newspapers published images that were invariably pin sharp, whereas Hardy's pictures were often taken under poor lighting conditions, giving his stories a gritty urban reality. More than any other photographer, he captured the greyness of pre- and post-war London to stunning effect. Like many photojournalists of the day, most notably Henri Cartier-Bresson, he was a Leica disciple, which gave him the flexibility to take pictures anywhere and in sequence. Colleagues speak in awe of Hardy's extraordinarily quick responses to the fleeting moment, and his ability to evaluate a good picture instantaneously. Another colleague recounts the tale of Hardy elbowing a bishop out of the way while covering a religious procession with the words: 'Excuse me mate, you're in my light.' A compassionate and prodigious storyteller, Hardy may not be quite as fêted as his French counterpart and fellow Leica user, but a key figure in twentiethcentury photojournalism nonetheless.

Girls on Blackpool Promenade (1947)
The second world war was over and this picture captured the mood of Britain, a country with a new-found freedom, on the road to recovery. At the time it was deemed somewhat risqué on account of the amount of bare flesh on display.

[Left] Violin and Horns (1953)

Hardy had a knack for photographing the somewhat quirky and droll and this image of a violinist seated next to the horn section of the Halle Orchestra is a typical gem. The woman may be deep in concentration, but we are too gripped by her headscarf to notice.

[Below] Leap Frog (1948)

A group of boys from the Gorbals tenements in Glasgow are playing amongst the gravestones in a cemetery, probably the only piece of greenery in the inner-city area where they live. A poignant and wonderfully composed image from one of Britain's greatest photojournalists who produced pictures like this as a matter of course throughout a long and distinguished career.

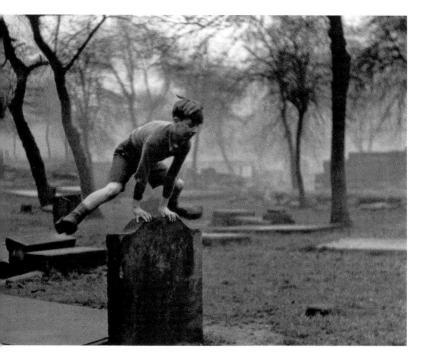

LEWIS HINE

BORN Oshkosh, Wisconsin, USA, 1874 DIED New York, USA, 1940 SOCIAL DOCUMENTARY PHOTOGRAPHER

Originally trained as a sociologist, Hine began to take pictures while teaching at the Ethical Culture School in New York. a humanist institution which stressed the worth and dignity of man. Inspired by a sense of injustice, between 1904-7 took pictures of immigrants arriving at Ellis Island. In 1909 he joined the National Child Labour Committee as an inspector and photographer. His survey of child labour took him far afield and prompted the US Congress to pass laws against the exploitation of children. After 1918. Hine worked for the Red Cross. and in 1931 undertook his most famous assignment: documenting the construction of the Empire State Building.

KEY BOOK America & Lewis Hine (1997)

For those who say that photography has the power to engage, but little beyond that, we present the case of Lewis Hine. His systematic and wide-ranging

documentation of child labour that took him to the mines of West Virginia, to the cotton mills of Carolina, to tiny kids picking potatoes in New Iersev, actually galvanized Congress into changing the labour laws. There is no objectivity about Hine's pictures; he is simply using all the means at his disposal to persuade his viewers that this can't go on. There is an obvious hook that draws us in that of nice, cute children having to perform difficult and sometimes dangerous tasks. On the one hand, these children are victims of a greedy system. But, on the other hand, in these beautiful photographs, they also become symbols for a better world. Similarly, with his Ellis Island project he embodies the immigrants with a sense of dignity. They are not statistics, but individuals who have struggled and who now look beyond the camera at the prospect of a better life in the New World. After the First World War, Hine's missionary drive abated somewhat and he became convinced - rightly or wrongly - that industrialization was a good thing and his pictures now reflected the joy of the working man. This is particularly apparent in his famous essay, The Construction of the Empire State Building (1931), where the builders take on the mantle of heroic workers possessing almost super-human powers. It is Hine's respect for the individual that marks him out as a true American photographer.

Newsboys under the Brooklyn Bridge (1912)
Hine was primarily a campaigner for social change, but he was also a perceptive and passionate photographer. In this picture he manages to capture a facet of each of the boys and gives them a humanity which makes us care about their fate.

[Left] Steam Fitter (1920)

A wonderfully composed picture that is full of rich detail and hidden meaning. The man is bowing to the machine, suggesting almost a level of subservience but his expression and powerful shoulders give him an innate dignity.

[Below] Child Labor: Girls in Factory (1908)

There is always a paradox in Hine's work, in that he photographs very cute kids carrying out difficult, grimy and monotonous tasks. Then again, the cuter the kid the more impact the picture is likely to have on the viewer.

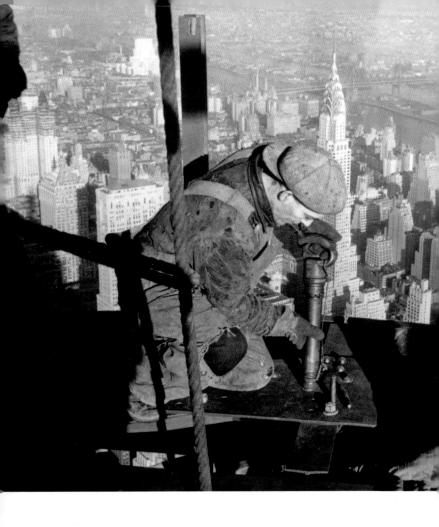

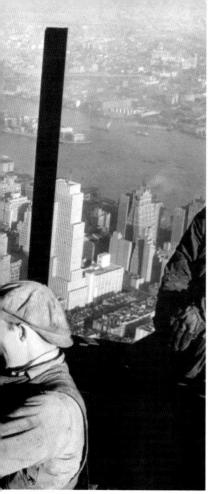

Workers, Empire State Building (1931)
By the time this picture was taken, Hine had become less critical of the impact of industrialisation and this famous essay almost takes on the mantel of a eulogy to progress and the heroic stance of the working man. A classic shot.

CANDIDA HÖFER

BORN Eberswalde, Germany, 1944 FINE-ART PHOTOGRAPHER

Candida Höfer's debt to her teachers Bernd and Hilla Becher is immediately apparent in her hyper-detailed serial images - but so is her unique take on the post-conceptual photography tradition that the Bechers initiated. Höfer began working as a portrait photographer for newspapers in 1968, and in 1973 she enrolled in Düsseldorf Kunstakademie to study film, transferring to Bernd Becher's photography class in 1976. Her most famous series, 'Räume' (Spaces), begun in 1980, is concerned with 'the presentation of culturally made objects in spaces – and the spaces themselves as such objects, the presentation of presentation, if you like'. Since her first solo exhibition in 1975, Höfer's work has been included in numerous group and solo shows, including a major retrospective titled 'Candida Höfer: Architecture of Absence' at West Palm Beach in 2006.

KEY BOOK Candida Höfer: Architecture of Absence (2006) Organization - of spaces, information and people - is the subject of Candida Höfer's relentlessly focused work. From the tiered arches of baroque theatres and the infinite recession of library shelves to serried ranks of classroom chairs and rows upon rows of paintings in the Louvre, Höfer takes the serial explorations of her Becher classmates (such as Thomas Struth and Andreas Gurskyl and turns them back on themselves. By tracing the mutations of the post-Enlightenment mania for classification through time and space – from the eighteenth-century wood-panelled classicism of Trinity College Library in Dublin, to a minimalist backstage store room at the New York Met - Höfer reveals the all-pervasiveness of what Derrida called 'archive fever' in Western culture. Her own images, taken with a large-format camera, are simultaneously an exemplar and critique of this mania: from the kind of dead-square perspective usually employed by architectural photographers, her 'Räume' series reveals in hallucinatory detail the structural logic behind our cultural institutions by accumulating a typology of libraries, universities, concert halls, archives and galleries. In a separate series on zoos, Höfer shows how people organize fhe natural world too, by categorizing and displaying living creatures as if they were minerals or files. As with most of her images, these pictures are titled with their exact locations, thus revealing the surreal effects of globalization and the human urae for the exotic: as a result of which we have elephants in Hamburg, giraffes (in a bizarre tromp l'oeil enclosure) in Paris, and penguins in London. Höfer has also explored

Library | London (1984)

The reading room of the British Museum (formerly the British Library), where Marx wrote Das Kapital, was modelled on the Pantheon in Rome, but uses the highest Victorian technology with a cast iron dome and modern ventilation and heating systems.

the serial projects of other artists, and how the context in which they are displayed affects their meanings. By depicting the location of all 12 casts of Rodin's 'Burghers of Calais' and, in another series, showing examples of conceptual painter On Kawara's 'Date Paintings' in the homes of private collectors, she also shows how these artworks affect their contexts. Another series focuses on the context of art alone: with her images of galleries in the Louvre she tackles a similar subject as Thomas Struth's museum

interiors, but unlike Struth, Höfer eliminates visitors from the frame. By stepping back from the individual artwork, she also removes the mystique of the art object and reveals these institutions as gigantic filing systems for objects. Though humans are almost totally absent from her chilly, enormous prints, objects like empty benches, chairs and desks show how these man-made spaces organize not just culture, but also people: as Derrida put it, 'archivization produces as much as it records.'

HORST P. HORST

BORN Weissenfels, Germany, 1906 DIED Palm Beach, Florida, USA, 1999 **FASHION PHOTOGRAPHER**

Horst originally went to Paris to study architecture but became interested in photography and fashion through his friend, Hoyningen-Heune. In 1934 succeeded him as Vogue fashion photographer, the magazine to which he remained loyal for much of his working life. Associated with a particular style of fashion photography inspired by classical painting and Greek sculpture, in which beauty is very much idealized and at times fetishized. His golden period was the 1930s and 1940s, when his vision of a distant and unapproachable sensuality was de rigueur. He continued working long after the war.

KEY BOOK Horst – Sixty Years of Photography (1991)

In the 1930s, the USA was experiencing the Great Depression. It was a time of hardship and people were looking for

means of escape. One route was through Hollywood and the magic of the movies; another alternative was through fashion and, in particular, the glossy pages of magazines such as Voque and Harper's Bazaar. The clothes may have been out of the price range of most readers, but looking and dreaming was free. Fashion photography therefore could not be arounded in reality; it had to be about the selling of dreams, where the women, the clothes and even the props are flawless creations. Horst is not just depicting an item of clothing, but a whole scenario of subtle wealth and taste in which the clothes feature, rather than take centre stage. It is an illusion, a celebration of what people did not have, but could imagine. Horst would get his models to imitate classical poses and he paid meticulous attention to detail such as the positioning of the hands, the precise angle at which the neck should turn and the way a piece of fabric should hang off the model. He was also fond of keeping everything quite sparse; too much clutter in the photograph and he felt the illusion would be lost. These pictures are too detached to be truly seductive and compared to today's hyper-real fashion photography; they appear staged and stilted. Horst revered the fantasy of fashion and his photographs are mementoes to this devotion.

Evening Gown by Schiaparelli, New York (1940)
This picture was taken shortly after Horst had escaped from wartorn Europe and settled in the States. Despite his personal traumas, his eye for elegant understatement remained undiminished.

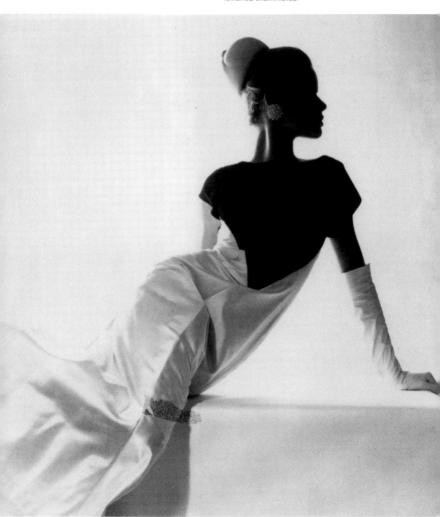

[Left] Gloves, New York (1947)

Horst often flirted with the viewer by partly concealing the model's face or photographing her in half light or in profile. His love for fabric and texture is what really makes this picture come alive.

[Below] Loretta Young, New York (1941) Once he moved to the States, Horst embarked on a secondary career as a Hollywood portrait photographer. His strength? He made his subjects look beautiful and seductive.

ERIC HOSKING

BORN London, UK, 1909 DIED London, UK, 1991 BIRD PHOTOGRAPHER

Self taught, Hosking left school at the age of fifteen and originally worked as an apprentice in a garage and as a salesman, In 1926, started career as a freelance bird and wildlife photographer working for newspapers and magazines such as Picture Post and Country Life. An inveterate traveller, his enthusiasm for birds took him as far afield as Alaska New Zealand, the Sevchelles and India. Winner of many photographic and natural history awards, he also published many technical manuals on nature photography, one of which (see below) is still regarded as the definitive guide. Received an OBE in 1967.

KEY BOOK The Art of Bird Photography (1944)

When Eric Hosking first started taking pictures of birds back in the 1920s, the odds were heavily stacked against him. First, there wasn't really a market for

wildlife pictures and there was not the same interest in the natural world as there is today. Secondly, the equipment was extremely bulky, it required pre-focusing and was laborious and time consuming hardly ideal kit for climbing up trees and for capturing on film creatures in flight. Yet despite these commercial and technical limitations. Hosking persevered and his pictures were so good that he virtually created a market single-handedly. He had the ability to freeze himself for hours at a time as he lay in wait for the returning bird. Technology came to Hosking's aid by the mid-1930s with the introduction of new flash bulbs which meant that he could take pictures at night, when birds such as owls are at their most active. Hosking actually lost the sight of one eye after being attacked by an owl at night - but he still managed to get a picture of his assailant. His photographs quite starkly reveal the physical characteristics of the birds: their feathers, wings, the shape of their beaks, their eves and the way they fly, nest and gather food. By today's standards, these photographs are relatively straightforward but they are highly effective nonetheless. Just imagine what Hosking could have achieved with today's technology if he were alive today. A pioneering photographer who has inspired many to take up the medium, be it professionals or amateurs

Barn Owl (1977)

There is something instantly alluring about a bird in flight and Hosking had a sixth sense for capturing the actual movement that propels the owl into the air. Note the detail on the wings.

GEORGE HOYNINGEN-HUENE (HH)

BORN St. Petersburg, Russia, 1900 DIED Los Angeles, USA, 1968 FASHION AND PORTRAIT PHOTOGRAPHER

Generally regarded as one of the great fashion photographers of the 1920s and 1930s. Career began after he moved to Paris in the 1920s. He studied painting, worked as a movie extra and befriended many famous Bohemians of the period. In 1925, hired by Voque and worked there for the next ten years. In 1935, moved to New York and worked almost exclusively for Harper's Bazaar, In 1943, he published his picture books: Hellos and Egypt. In 1946, moved to Hollywood and became a sought-after portrait photographer. Was a friend of Horst and their careers were very much intertwined

KEY BOOK The Elegance of the 1930s (1986)

Hoyningen-Huene's fashion photographs are as much a celebration of the human body as they are of the clothes that adorn it. His picture 'Swimwear by

Izod' (1930), which depicts the models almost as sculptures, has influenced more current fashion photographers than some would care to admit. The 1920s saw an emergence of body culture. People began to take better care of themselves, exercise more and appreciate the benefits of fresh air, open spaces and sun bathing (this was pre skin cancer). Many of HH's pictures revel in the sheer physicality of his models. Like Horst, he was inspired by classical poses and his models are flawless beings who are lit in such a way that they appear as if they have descended from Mount Olympus to show off a new range of swimwear, or the latest line of evening wear. As a reaction to the First Word War. artists also wanted to liberate themselves from traditional means of expression and were keen to explore different ways of seeing and interpreting the world. This too influenced HH, who tried to introduce a dash of surrealism into some of his fashion work with mixed results. He later had an impressive second career as a Hollywood portrait photographer. Fashion gave him the perfect grounding to work in another realm of fantasy. Always a master of lighting and cropping, he was experimental enough to attract the attention of the top stars of the day, including the moody Greta Garbo. But he always knew when to draw the line with experimentation. While his pictures never challenge, they have a timeless beauty.

Swimwear by Izod [1930]

One of the century's most enduring fashion photographs.

It has a timeless simplicity to it, is highly seductive and shows off the swimsuits. What more could one ask for from a fashion picture?

GRACIELA ITURBIDE

BORN Mexico City, Mexico, 1942 SOCIAL DOCUMENTARY

One of the biggest names in Latin American photography, Graciela Iturbide's work unearths pre-Columbian imagery in the search for a modern Mexican identity. After losing her child and divorcing her husband she enrolled at the Universidad Nacional Autónoma de México. There, from 1969-72 she studied cinema and met the father of Mexican photography, Manuel Álvarez Bravo, who became her mentor. Though she has remained focused on Mexico throughout her career, she has also worked in India, Argentina and Texas. She first exhibited in Mexico City in 1975. She was a founding member of the Mexican Council of Photography, and in 2008 she received the Hasselblad Foundation Award

KEY BOOK Eyes to Fly With (2006)

Graciela Iturbide's dreamlike, sinister and spine-tingling photographs attempt to connect us with the ancient culture of her Mexican homeland. But as one of her most striking early images reveals, this is not a straightforward return to roots. Asked in 1979 to photograph a Seri village for the archive of the National Indigenous Institute, Iturbide traveled to the Sonoran Desert where she found former nomads living in seemingly undisturbed, pre-modern conditions, intimately connected with the harsh terrain. Of this picture Iturbide said 'I call her "Mujer Ángel" [Angel Woman] because she looks as if she could fly off into the desert.' But this angel, though wearing traditional clothes and striding into a vast and ancient landscape, carries in her hand a very modern boombox. As a photographer, perhaps Iturbide was interested by this hunk of technology in the woman's hand: like a camera, it is a mechanical medium but not necessarily out of sympathy with the primeval surroundings. 'She was carrying a tape recorder, which the Seris got from the Americans, in exchange for handicrafts such as baskets and carvings. so they could listen to Mexican music... I liked the fact that they were autonomous and hadn't lost their traditions, but had taken what they needed from American culture.' Later that year Iturbide visited the town of Juchitán in the southwestern region of Oaxaca, where the community follows an ancient tradition of matriarchy. There, Mexican machismo is crushed beneath the high-heel of a female-dominated society, and

Mujer Ángel [Angel Woman] (1979)

An angel with a boombox strides the ancient landscape of Mexico: a metaphor for the sympathy of the camera with its 'anachronistic' subjects.

transvestitism and homosexuality are not just tolerated but positively encouraged (in an image titled 'Magnolia', Iturbide shows a local man with a lipstick-darkened mouth). Made famous among artists after a visit by muralist Diego Rivera in the early 1920s, Juchitán was later a site of pilgrimage for Frida Kahlo, Henry Cartier-Bresson and Edward Weston. However, the most famous image of luchitán is Iturbide's portrait of a

local woman, her head wreathed Medusalike with living lizards (she is selling them in the marketplace for food). The photograph is titled 'Our Lady of the Iguanas' (1979), but unlike the Catholic gods brought by the Conquistadors, this is a goddess on earth. The photograph was adopted by the villagers as a kind of emblem: a powerful testimony to Iturbide's ability to portray her subjects as they see themselves.

NADAV KANDER

BORN Tel Aviv, Israel, 1961 ADVERTISING/FINE-ART PHOTOGRAPHER

One of the world's most innovative and consistent advertising photographers. Grew up in South Africa from 1964. until he moved to London in 1982. Set up own studio in 1986. Has worked on many high profile worldwide campaigns including: Nike, Levi's, Absolute Vodka, Lufthansa, Tag Hero, Issey Miyake, Amnesty International, Umbro, Häagen Dazs and Silk Cut. His work also forms part of the public collection at the Victoria and Albert Museum in London In 1999 won the Alfred Eisenstadt Award for a sports photograph, and has also won countless advertising awards both in the UK and Europe.

Nadav Kander says: 'I try to approach similar projects from a different perspective – I feel dissatisfied when repeating myself.' Well, there is no danger of that. Most advertising photographers are good at certain things - for instance, shooting cars, landscapes, portraits, or still lives - usually under careful auidance of the art director. Kander by contrast can shoot anything in any style; using a variety of formats; in colour or black and white; photographed from what he calls 'a personal and hopefully interesting perspective'. Kander is technically outstanding, but it is this personal stamp. coupled with his versatility, that separates him from almost any other photographer. If he was a photojournalist or fine-art photographer his remarkable talent would be universally lauded, but because he is operating in a commercial environment with big budgets and demanding clients, it is too often overlooked. Kander has the ability to strip down an image to its bare essentials. Everything in the frame is there for a reason, and often it is the purity of the pictures that gives them such an undeniable power. He is also fascinated with the whole process and history of the medium, and unusually for such a successful photographer he still prints much of his output. His personal work often takes the form of quite melancholy portraits where there is a sense of unease. even friction, between the sitter and the photographer. Kander says his pictures do not bare his soul, but when images are that striking, something of the image maker's personality inevitably goes into the photograph - and it is better for it.

Body (1998)

In this picture the human body seamlessly merges into the natural landscape. This highly evocative image strips everything down to its bare essentials both literally and metaphorically.

YOUSUF KARSH

BORN Mardin, Armenia, 1908 DIED Boston, USA, 2002 PORTRAIT PHOTOGRAPHER

Karsh is best known for his portraits of political and cultural leaders of the 1940s and 1950s, most notably his picture of a glowering Churchill taken in 1941. Emigrated to Canada in 1924. and his interest in photography was aroused by working in his uncle's portrait studio in Montreal between 1926 and 1928. Then trained in Boston with John Garo, also a portrait photographer. Shortly afterwards, set up his own studio in Ottawa, in 1932. Also worked as an industrial and corporate photographer. Winner of countless awards and fellowships. Karsh has also been exhibited worldwide since the 1950s and has published many books.

KEY BOOK Karsh Portraits (1976)

Karsh's picture of Churchill, which made the cover of *Life* magazine in 1941, is one of the most famous portraits of the twentieth century. Legend has it that the session was not going well. Churchill was not responding to the photographer's directions and Karsh in turn was irritated by the great man's cigar. Karsh, not one to be intimidated by reputations, swiped Churchill's cigar and then started shooting. This explains why Churchill is looking more like a grumpy old man than a war hero. The portrait shows a vulnerable side to Churchill; it is also remarkably candid. Like the best portraits, it uncovers something about the sitter, a trait or quirk of some sort that until that moment had been suppressed. Karsh says his aims are twofold: 'to stir the emotions of the viewer and to lav bare the soul of the subject.' Karsh's pictures are grand and formal affairs. They are akin to Edwardian portraits of the turn of the century when both the subject and viewer are extremely conscious of a picture being taken. The sitter is quite obviously posing under the guidance of the photographer, and the picture is lit and composed in a style that intensifies our awareness that this is a controlled situation. Karsh is interested in the 'inward power' of his subjects, hence why he was more drawn to photograph famous people. He did take pictures of the 'common man' but doubted whether an image of an unknown could have the same appeal for the audience - and more crucially, for the photographer himself.

Winston Churchill (1941)

One of the contenders for the most famous portrait of the century and evidence that some of the best pictures occur when there is an element of tension between the photographer and the sitter.

Brush Stroke of Genius (1981)

Karsh has always preferred taking portraits under studio conditions, preferably with the sitter placed against a dark background. The twist in this picture is that Andy Warhol, the pop artist, is photographed with a broad decorator's brush.

Nelson Mandela (1990)

One of the great leaders of the twentieth century in typically relaxed pose, quite a contrast from Karsh's portrait of Winston Churchill. The placing of the hands can present difficulties in portraits, but Karsh gets round the problem effortlessly.

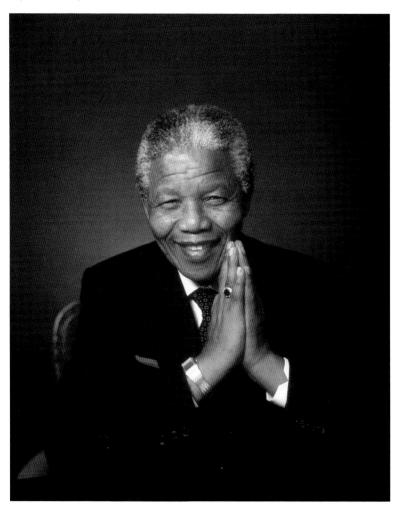

andré kertész

BORN Budapest, Hungary, 1894 DIED New York, USA, 1985 FINE-ART PHOTOGRAPHER

A gifted amateur photographer before moving to Paris in 1925, Kertesz developed a lyrical form of 'new vision' modernism in his work for the emergent illustrated press. He exploited the visual freedom offered by the new Leica 35 mm camera to great effect, but also experimented with distortion and photographic effects. His publications on children (1933) and Paris (1934) were pioneering publications in the new genre of the photographic book. Moving to New York in 1936, he remained an editorial photographer for the rest of his career. After retirement he continued to photograph, and was 'rediscovered' towards the end of his life.

KEY BOOK André Kertész: His Life and Work (1994)

When Beaumont Newhall was assembling his historic exhibition at MoMA (the Museum of Modern Art in New York) in 1937 known as 'Photography 1839–1937', he asked Kertesz – recently arrived in the city – for some prints. The Hungarian proposed his

series of distorted nudes, published to great acclaim in France in 1933. Newhall, with typical ascetic New Englander zeal, insisted that if shown they would have to be cropped so the pubic hair was not evident. The photographer reluctantly agreed, but held it against Newhall ever after. As he ruefully recalled, 'This was my welcome to America'. Kertesz had the ability to combine fascinating modernist compositions with an evanescent and mysterious quality. His classic images of the Eiffel Tower (1927), of his friend Mondrian's studio (1926) and of the Satiric dancer (1927) defined a style which would later be exploited by others, including his compatriot Brassaï and Henri Cartier-Bresson. The irony of his decision to go to America he left Paris in 1936 just after a long-delayed decision to allow him French nationality came through - is that his adopted country had little idea how to use his remarkable, 'lyrical-Modernist' vision. The Keystone agency, who offered him the job which took him to New York, made him do studio work, when his forte was the street, the 'circumstantial magic' of the decisive moment (invented well before Cartier-Bresson), and grasped with a small camera. Virtually all his best work in the USA was made as part of personal projects: the famous series of pictures from his apartment window of Washington Square is typical. It was not until he gave up his job in 1962, and shortly after rediscovered his Hungarian and Paris negatives of the period 1912-36, that his reputation revived.

Le Square Jolivet à Montparnasse, Paris (1927)
An understated and tranquil urban scene of Paris at night. There is a nice interplay between the trees and the lights, confirming that Kertesz possesses a Modernist lyrical vision.

Une Fenêtre Nu, le Quai Voltaire, Paris (1928) Reality is temporarily suspended in this image as the statues almost come to life. We are at first glance deceived into thinking these are real people but closer observation reveals that this is a clever illusion. Nevertheless the picture leaves us slightly uneasy.

Chez Mondrian (1926)

Kertesz was a great friend of the painter Mondrian, and this is taken at his home. The image is highly graphic, as if the photographer is trying to incorporate elements of the painter's technique and style into his own pictures.

WILLIAM KLEIN

BORN New York, USA, 1928 SOCIAL DOCUMENTARY, FINE-ART AND FASHION PHOTOGRAPHER

William Klein is not easy to categorize. One of the more eccentric figures in post-war American photography, he saw himself as an outsider. He grew up in New York and after a short stint in the army went to Paris in order to pursue a career in painting. Returned to New York in 1956 where he had a dual career, both as assistant art director for Voque and subversive photographer that culminated in his seminal book. Life is Good and Good For You in New York in which he rewrote many of the rules of the medium. In the 1960s made documentary films and, after falling out of fashion in the 1970s, came back into voque in the late 1980s.

KEY BOOK New York (1995)

You can forget objectivity in William Klein's photography. His 1950s book of his native city is very much a personal statement about how he felt about the world. He expressed himself by creating a new visual language that screams out at the viewer. The chaos,

paranoia and absurdity of city life is conveyed by Klein furiously juxtaposing images across pages. He uses fast films, wide-anale lenses, blur, grain, contrast, flash effects, with everything pushed to its absolute limits. The printing and framing is erratic and unconventional and some of the images are so abstract that they are almost indecipherable. Not surprisingly, the public reaction was mixed. Undeterred, Klein adapted this same approach to Moscow, Tokyo and Rome. We learn a areat deal about Klein's knee-jerk reaction to the cities and their inhabitants, but little about the places themselves. It is a strange social documentary drama in which the photographer is always playing the central role. At the same time he was producing these unconventional travelogues, Klein was also applying these techniques and preoccupations to his commercial fashion work, but with more restraint. Klein is ambivalent about fashion and some of his work is laced with an irony and post-modern sensibility that was way ahead of its time. He wanted to take real pictures in an industry that thrives on selling fantasies, so he reconciled this by often placing models in quite threatening urban environments. Klein's images are not conventional: some of them are not even always successful. But as a body of work, his influence in the areas of publishing, design and, of course, photography is considerable.

Constructivist Dancers, Bicentennial parade, Paris [1989] Klein always wants the viewer to know that what they are seeing is a highly subjective interpretation of the scene presented to them. The printed contact sheet leaves us in no doubt that the photographer is the one calling the shots and he is observing on our behalf.

Backstage, Christian Lacroix, Paris (1992) Klein here is trying to capture the chaos and frenzy of a fashion show. Many of his trademarks such as blur, close up and dramatic use of flash can be seen in this picture. This is part of a series that heralded Klein's return to the world of fashion .

HEINZ KLUETMEIER

BORN Berlin, Germany, 1943 SPORTS PHOTOGRAPHER

Generally acknowledged as one of the world's top sports photographers. Raised in Milwaukee, Wisconsin, he began shooting pictures for the Associated Press by the age of 15. After leaving school he was offered a full-time job, but studied engineering instead and between 1966 and 1967 worked as an engineer for a steel company. Yet photography is his calling and in 1969 he joined the staff of Time, and also worked for Sports Illustrated and Life. He has shot more than 100 covers for SI, and between 1992 and 1996 was the magazine's director of photography. He continues to cover all the main sporting events including the Olympics, the Super Bowl and the World Series.

By the late 1960s, sport was a huge, global, media phenomenon. It had always been popular, but colour TV and its link with commercial sponsorship ensured that events such as the Olympics, the

World Cup and the major golf and tennis championships were being watched by hundreds of millions of people. One would surmise that colour TV would signal the death of still sports photography but the reverse is what occurred. People saw their sporting heroes for fleeting moments on TV, but magazines such as Sports Illustrated provided in-depth profiles and pictures that went beyond mere action shots. New autofocus cameras could now fire so many frames per second that in terms of speed they competed with the immediacy of TV cameras. Colour film emulsion technology also made rapid strides during this period, giving sports pictures an even greater impact. Into this arena stepped Heinz Kluetmeier, whose pictures always draw the viewer into the emotions of the moment: the instant of victory or defeat, triumph and despair, joy or sadness. As he says: 'The thing to remember about sports is that more often than not, the emotional reaction to winning or losing is a more significant picture than the touchdown being scored, or the home run being hit." The best sports photographers are those who can react to something quickly, both technically and emotionally, and can frame a picture in their head as they are shooting. Kluetmeier has these abilities and can always find something fresh in welldocumented sporting events.

Raymond Brown at the National Collegiate Amateur
Athletics Men's NCAA Swimming Finals (1989)
Swimming is one of those sports that gives the
photographer freedom to explore their more creative
sides. This swimmer, with his head bobbing in and out of
the water and his goggles, looks more like an amphibian
than a sportsman.

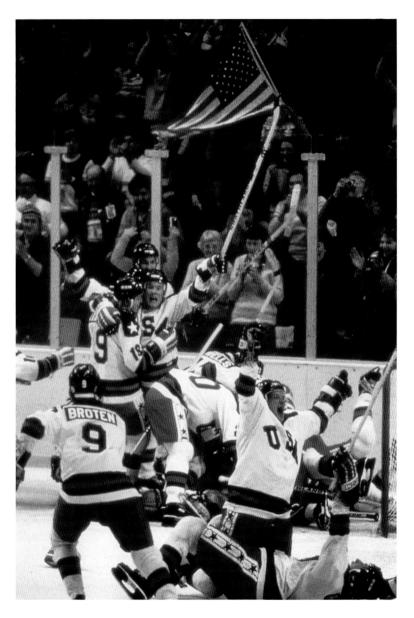

[Left] Ice Hockey, Olympic Games (1980) Kluetmeier's pictures always draw the viewer into the emotions of the moment and in this image we see the pure unadulterated joy of victory in a crucial ice hockey match.

[Below] Michael Johnson, Texas (1991) This peerless 400-metre champion is easily recognizable by his straight-backed running style which Kluetmeier captures in a blur of movement.

NICK KNIGHT

BORN London, UK, 1958 FASHION AND MUSIC PHOTOGRAPHER

One of the most important fashion photographers working today. After studying photography in the south of England, started working for cutting edge British style magazines such as The Face and i-D in the early 1980s. From there araduated to more mainstream fashion publications such as Vogue and has shot campaigns for Reebok, Iill Sander, Christian Dior and Yohii Yamamoto. Work has crossed into the realms of fine art and has been widely exhibited. Was one of the first commercial photographers to recognize the potential of digital imaging. Knight has also been the recipient of numerous prizes and awards.

KEY WORK: Nicknight (1994)

Nick Knight's rise coincided with the rebirth of England as a centre for style, for radical fashion and for an innovative way of presenting it. In his early days, Knight was very much seen as a London photographer who had his finger on the

pulse of street culture as opposed to high fashion. Yet within a comparatively short space of time, he was working for some of the world's top designers. Knight's work is subversive: there is an edge to his pictures and an ambivalence towards the fashion industry as a whole. Yet at the same time, there is tremendous respect for the fabrics themselves. In the pictures you see a fellow craftsman acknowledging the skill and vision that has gone into the clothes' creation. Many of his images are cross-processed (where slide film is put through a negative film developer) and he lights the pictures using ring flash, which jazzes up colours and gives them added sheen. In his campaign for Yohji Yamamoto, the seduction is complete; the models may be mesmerizing, but what we really want to get our hands on are those beautiful clothes. Whereas most fashion photographers are subject to the fickleness of current tastes and what is deemed hot at the time, Knight has managed constantly to reinvent himself as more than just a fashion photographer. The Natural History Museum in London houses a permanent exhibition of his images of plants and flowers produced on a Quantel Paintbox. More recently, he has been experimenting with surveillance cameras and using senior citizens for fashion campaigns. An innovator with a strong commercial sensibility: always a winning combination.

Susie Smoking (1988)

This is part of a groundbreaking campaign for the Japanese designer Yohji Yamamoto and is one of Knight's most famous images. It may not be politically correct to say so, but this picture makes smoking seem highly appealing. The use of colour is quite brilliant.

[Left] Devon (1996)

Shot for the magazine Visionaire and featuring the work of British designer Alexander McQueen. A disturbing image that cannot fail to provoke some kind of response in the reader. The model comes across as a well-dressed alien who has just had a nasty car crash.

[Below] For Yohji Yamamoto (1986)

Although he maybe a bold innovator, Knight never forgets that it is the clothes that must dominate the picture. This picture is all about subtle curves and the way the fabric hangs off the model at just the right angle.

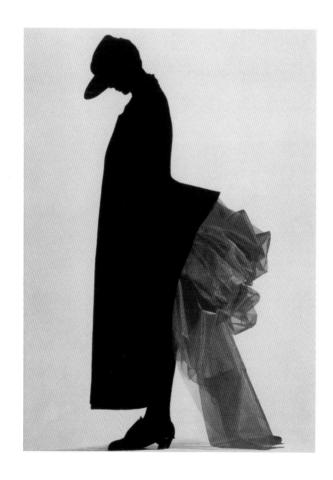

DOROTHEA LANGE

BORN Hoboken, New Jersey, USA, 1895 DIED San Francisco, USA, 1965 PHOTOJOURNALIST

Lange's childhood was marked by disability (from polio) and personal loss ther father deserted the family when she was 12). She learned large-format portraiture at the Clarence White School in New York in 1917. Moving to San Francisco in 1918, she set up a successful portrait studio and married the Western painter Maynard Dixon in 1920. After 1929, Dixon and Lange drifted apart, and from 1932 she progressively abandoned portraiture for social documentation. From 1934-9, Lange worked closely with Paul S. Taylor (her second husband) on social problems of the rural depression, in part for the Farm Security Administration. A Guggenheim award in 1941 was followed by work on US internment camps for Japanese nationals. Postwar, she travelled extensively with her husband, and spent 1954-55 as a photographer for Life.

KEY BOOK Dorothea Lange: American Photographs (1994)

Assessing Lange's career can only really be done in the context of one image. A woman with a keen social conscience, Lange joined the FSA on a mission to document the precarious hand-to-mouth existence of the migrant rural workers. Lange discovered a woman and her family in the Nipomo Valley, California, after travelling extensively there and in the south-western states. The location was a pea pickers' camp and the unnamed women told Lange that she and her three children were living on frozen vegetables. The strength of the picture lies in composition and the woman's direct and unflinching gaze. She is only thirty-two; lines and wrinkles are already etched on to her face; and yet it is not a picture of despair. Within all that suffering, there is also pride and dignity, a feeling that somehow the migrant worker and her family will get by, and a hope for a better life. When the picture was first seen it was immediately taken up by the FSA and used for propaganda purposes. As an epilogue to this image, one of the three surviving children was reportedly seeking a share of the royalties generated by this picture. She was not successful.

Migrant Mother (1936)

One of the most famous photographs of the twentieth century, which became a symbol for the hardships and struggle for survival amongst ordinary folk as the Great Depression swept through America in the 1930s.

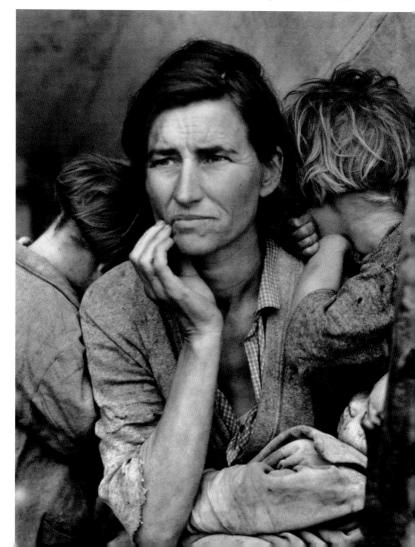

FRANS LANTING

BORN Rotterdam, Netherlands, 1951 WILDLIFE/CONSERVATION **PHOTOGRAPHER**

Generally acclaimed as the world's greatest living wildlife photographer, although he prefers the term conservation. Started taking pictures while on holiday in the USA from his native Holland: first while hiking in the National Parks: and later shot his first wildlife story on the fortunes of migrating geese while studying at the University of Santa Cruz. A dedicated and highly skilled craftsman, his images have been published in Geo, Life and National Geographic and he has also been exhibited worldwide, as well as having a lucrative sideline in selling prints, posters and videos.

KEY BOOK Eye to Eye (1997)

There are many misconceptions about wildlife photography. There is the widespread belief that it is all about being in the right place at the right time. The

millions of amateurs who take these sort of pictures say that if they had the time and equipment their images could match those of any professional. This theory may ring true in some instances, but not in the case of Frans Lanting. He has elevated the genre into an art form which is beyond emulation. He has been described as having 'the mind of a scientist, the heart of a hunter and the eye of a poet'. A hunter, however, pursues his prey with a gun, hell-bent on killing. Lanting by contrast uses a camera with the aim of preserving that which he photographs. For example, his pictures of the culling of elephants in Botswana resulted in a siege of the country's embassy in Washington. His empathy with wildlife is almost supernatural, enabling him to get as close as possible to his subjects. The beauty of the beasts and the birds is always perfectly captured in glorious light, but Lanting goes beyond the traditional animal portrait. His images also illustrate how the animals interact with each other, their characteristics, their precarious future and how the creatures merge into the natural landscape. The work of Franz Lanting must be treasured for two reasons. First, as ravishing pictures in their own right. Secondly, as evidence that these animals are God's own and must be allowed to flourish in the twenty-first century.

Two Orang-Utans (1991)

Cute, very cute primates in their natural habitat. Lanting's pictures are often the result of weeks of quiet observation and he is a master at blending into the natural habitat.

[Left] Nile Crocodile Hatching, Botswana (1989)
Lanting has the uncanny ability to get as close to wild animals as is humanly possible and is often prepared to wait patiently for days on end for the decisive moment.

The baby crocodile looks suitably bemused as it takes stock of its new environment.

[Below] Sitatunga Running, Botswana (1988)
Lanting's pictures go beyond the traditional animal portrait
and he is as much interested in the natural habitat where
the beast resides as in the animal itself. This image also
demonstrates Lanting's skill in capturing movement.

JACQUES-HENRI LARTIGUE

BORN Courbevoie, France, 1894 DIED Paris, France, 1986 FINE ART AND DOCUMENTARY **PHOTOGRAPHER**

Son of a wealthy family, Lartique was given a camera for his seventh birthday, and began to make intriguing images of the life around him, forming part of the journal that he kept from 1900 to his death. In 1922 he became a painter. and worked as an artist and illustrator for most of his life. From 1950, his photographs begin to appear in the press. Helped found the photographic society 'Gens d'Image' in 1954, and his first photographic exhibition in 1955 was followed by a MoMA New York show in 1963. The book Diary of a Century (conceived by Avedon) appeared in 1970. Donated his work to the French State in 1979.

KEY BOOK Jacques-Henri Lartique (1998)

Jacques-Henri Lartique's work was hardly known beyond a small circle of associates until the 1960s, yet he had produced a huge body of exciting photographs during the period between 1902 and 1940. He is difficult to place in art-historical models of photo-history since his work was made for purely private reasons: pictures of his well-to-do family, his friends, his wives and lovers; all carefully assembled in journals and albums. Lartigue was a child prodigy who began to make impressive pictures with a large-format plate camera in 1902, when he was eight years old. Despite the apparent limitations of this medium, his pictures delight in movement and capture the spirit of play and simple domestic pleasures. Lartique did little more than photograph his life; and his work (which includes many pictures made in a dynamic panoramic format) encapsulates his obsession with happiness. Whether illustrating his brother's fascination with flying machines, elegant women in the Bois de Boulogne, a day at the French Grand Prix in 1912 (where he made one of the most intriguing pictures of the new century), or delighting in the languorous form of his young wife on the beach at Biarritz, Lartique photographed the pleasures of a gilded lifestyle. Egoistic, certainly, but intriguing nonetheless for its effortless composition, and delight in pleasure for its own sake. Although his style seems unencumbered by technical considerations, Lartigue had fully mastered the medium to the point where art and craft seem indistinguishable.

Bretagne (1971)

When Lartigue took this shot he was in his late seventies, but his fascination with the beautiful French seaside remained undiminished. His pictures delight in movement and in the spirit at play.

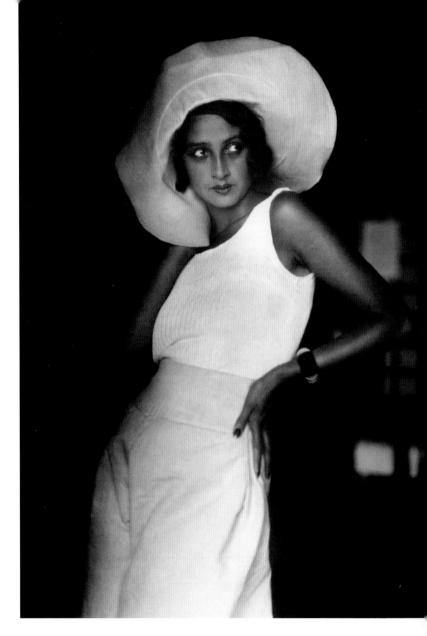

[Left] Aiat, Biarritz, Renée [1930]

It is unclear whether this is a portrait of a society beauty or a fashion shot, but either way it is a very stylish photograph. Her pose is somewhat unconventional as she appears to be almost arching her back, but the hat and her expression are sure-fire winners.

[Below] Avenue du Bois de Boulogne (1911) Lartigue was a member of a wealthy family himself and many of his pictures are celebrations of opulence and the elegance of the French upper middle classes. The period detail in this photograph is compelling and there is a nice contrast between the car and the horse and carriage.

O. WINSTON LINK

BORN New York, USA, 1914 DIED South Salem, USA, 2001 COMMERCIAL/INDUSTRIAL PHOTOGRAPHER

Link is best known for his seminal work. taken between 1955 and 1960. documenting the last of the steam locomotives operating on the Norfolk and Western Railway in West Virginia, Virginia and North Carolina Self taught, he worked as a PR photographer between 1937 and 1942; in 1942-45 worked for the Airborne Instruments Office, and 1945-87 worked as a self-employed industrial and commercial photographer which financed his personal obsession with steam trains. It was not until the mid-1970s that the N&W Railway work was reproduced and not until 1983 were the pictures exhibited. Now celebrated as one of the foremost US post-war documentary photographers.

KEY BOOK The Last Steam Railroad in America (1995)

Mention Link's name and people invariably say: 'Oh yes, he's that train photographer.' This only tells half the story. These formative pictures of steam trains with the smoke

billowing triumphantly over vast plains are indeed masterpieces for which Link is rightly revered, but they are more than just train pictures. Link worked on this project from 1955 to 1960 when America was experiencing huge social and economic changes. The automobile was becoming the king, super highways were being constructed at a rapid rate and the train was being usurped. The pictures are a mourning of a passing era, but also a celebration of small-town, American, trackside, rural life in the 1950s; the drivein movies, the main streets, the swimming holes and farmhouse porches that were being replaced by suburbs and shopping malls. America was losing its innocence, felt Link, and these pictures are an attempt to hold on to the old world. The reality of track life was somewhat more grimy and harsh, but Link really idealized the trains. The pictures are elaborately staged with the locomotives taking on a heroic status as they ride on through the night; another version of the cowboy riding into the sunset. Link pioneered a synchronized flash system, often using as many as fifteen flash units for one exposure, which enabled him to create high-contrast, dramatic, night-time scenes which even by today's standards look remarkably sharp. Indeed, his whole style of creating, lighting and shooting a scene ironically had a profound influence on advertising photography, in particular for automobiles.

Birmingham Special at Rural Retreat, Virginia (1957)
Link was a true master at photographing high-contrast,
night-lime scenes using a synchronised flash system, often
using as many as fifteen flash units for one system. The
name of the small town is almost too good to be true.

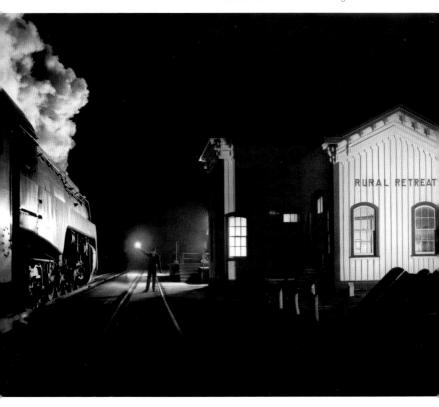

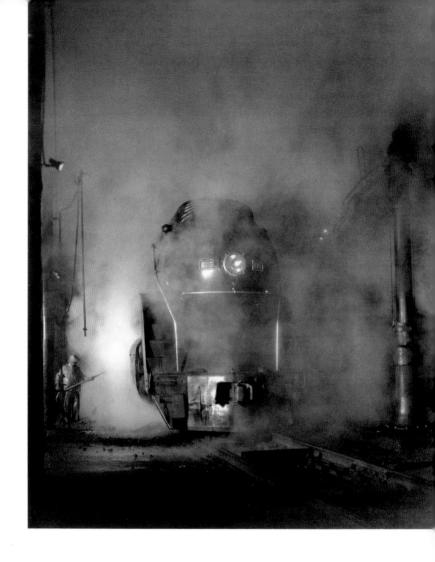

[Left] Washing J Class 605 at Shaffer's Crossing outside Roanake, Virginia (1955)

Link had a remarkable eye for perspective and opportunity, allied with his hard-won encyclopaedic understanding of lighting and the ability to wait patiently for things to happen. The placing of the man next to the train also gives the locomotive a true grandeur.

[Below] Train 201 at Bridge 11 (1955) The train hurtling through the American landscape with smoke billowing is a motif that Link returns to time and time again.

STEVE McCURRY

BORN Philadelphia, USA, 1950 DOCUMENTARY, ENVIRONMENTAL AND TRAVEL PHOTOGRAPHER

Graduated in 1974 from Penn State University with a B.A. in cinematography and history. In the late 1970s, went to India and Afahanistan - the countries with which his work is most closely identified - and freelanced for several international magazines. Career was launched when he crossed into rebelcontrolled Afahanistan in 1979, just before the Russians invaded. His highly distinctive colour photography, which combines the best elements of reportage, social documentary and travel work, has appeared in numerous publications but most noticeably in National Geographic. His images are in the permanent collections of the George Eastman House and the Houston Museum of Modern Art. A member of Magnum.

KEY BOOK Monsoon (1988)

There is something of a paradox about McCurry's work. On a technical level, his pictures are near perfect, beautiful colourful creations. Yet the content and

subject matter are often quite disturbing: poverty and rootlessness, despair and hunger. It is not that he lacks empathy with his subjects - quite the opposite in fact. His pictures are the result of painstaking research and constant travel. McCurry's approach is anthropological in scope: religion, culture and tradition are reflected in his pictures. News, as it unfolds, is placed in a wider context; and he is not interested in the dramatic shot for its own sake that only reveals, but does not enlighten. McCurry has gone against the grain by photographing India and many other Asian countries in colour. Think of most images from the subcontinent and they are invariably in black and white, but India for McCurrry is a country with a vast array of dazzling and conflicting sights, tastes and smells that can only be done justice in alorious colours. Hence the criticism in some quarters that his picture are just too slick for their own good. Yet this is a criticism born out of an inverted snobbery towards colour photography. It is generally held that black and white possesses a substance and depth that colour could never hope to replicate. However, one of the definitions of a great photographer is someone who pushes the barriers of the medium, and in so doing, their method becomes standard practice. McCurry fits into that category and more. His work is not just accepted, but lauded for its beauty and humanity.

Monsoon (1986)
Despite his predicament this man's face seems rather calm, as if he is used to a life of hardship.

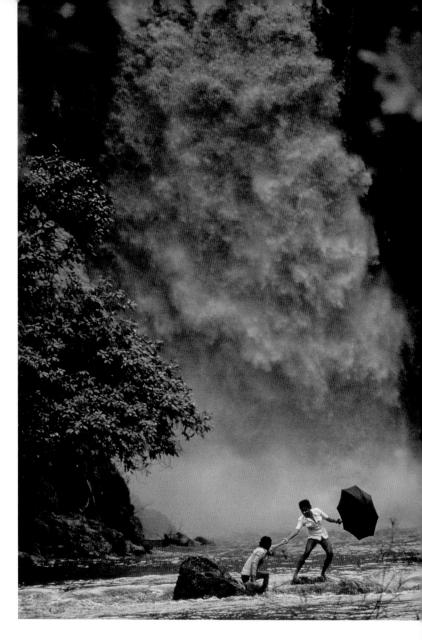

[Left] Monsoon (1986)

A dramatic shot with the story of survival unfolding before the viewer's eyes. There is also something faintly odd that while one man is clinging on to dear life, his would-be rescuer is hanging on to his umbrella.

[Below] Monsoon (1986)

The boy looks like a beetle with his painfully thin limbs and the leaf that covers his body like a shell. This picture illustrates that against powerful natural elements such as monsoon rain, man always appears to be fighting a losing battle.

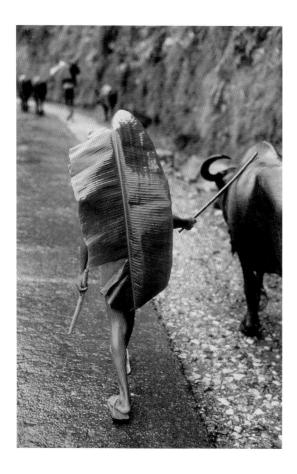

MARY ELLEN MARK

BORN Philadelphia, USA, 1940 SOCIAL DOCUMENTARY AND PORTRAIT PHOTOGRAPHER

Graduated in 1964 with a Masters degree in photography from the Annenberg School, although originally attracted to painting and drawing. Belonged to a group of committed, sympathetic and yet unsentimental 1960s photojournalists who recorded the experiences of people such as prostitutes, drug addicts and the sick. Work has appeared in Life, Stern, National Geographic and Rolling Stone, as well as hundreds of other publications. In the late 1960s started doing stills on films and this has led to an alternative career as a celebrity portraitist.

KEY BOOK Mary Ellen Mark's Indian Circus (1990)

Mary Ellen Mark is not one of those photographers who impose their personalities on the picture. Mark's philosophy has always been that 'portraits must tell me something about the person being photographed, not how clever the photographer is'. This has certainly been

her modus operandi. Whether it's taking pictures of Bombay prostitutes, movie stars, homeless teenagers on the streets of Seattle, junkies, circus freaks or Henry Miller, Mark always gives her subjects the chance to shine. It's as if she is saying: 'it's just you and me and the camera, so why don't you show me what you've got?' And almost invariably they do. She says her pictures of the downtrodden are a voice for them. But there is never a sense that it is a hectoring or preaching voice; the pictures work because of their very restraint: it is low key, but a voice that eloquently conveys the subject's experiences and hopes. Like all photographers with a liberal conscience, Mark has, at times, expressed unease about the exploitative nature of her profession. She has compared what she does to a hunt, yet at the same time recognizes that photography can be an instrument for change. Technically, her pictures are always kept very simple: black and white, with the clever use of light and space and the mastery of composition owing much to her fineart background. Yet this simplicity is deceptive. Look deeper and the person's history unravels before one's eyes. This is photography that reaches to the soul. She uses the same technique and approach in her pictures of celebrities, who often reveal more of themselves to her than to most other photographers.

Sylvester Stallone (1991)

An arresting shot of a Hollywood superstar posing with his dog. Both of them are turning away slightly from the camera and Stallone appears to be lost in thought. The point of the picture appears to be that he is a sensitive man who loves animals, but the effect is spoiled somewhat by his hairy and imposing forearm.

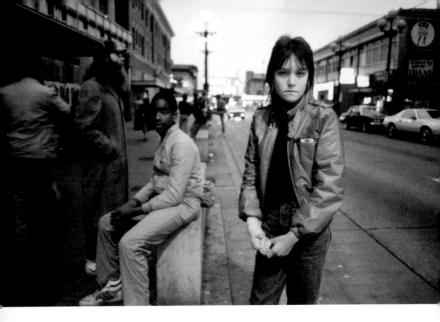

[Above] Streetwise (1983)
This is from one of Mark's more famous essays on homeless kids on the streets of Seattle. The children have that odd combination of vulnerability and defiance and you get a strong sense of their living environment

[Below] Streetwise (1983)

Mark neatly captures the dynamic between her two sitters. The boy, at least on the surface, appears to be very much in control, whereas his girlfriend is clearly looking to him for emotional support.

Falkland Road (1979)

India is a country that has fascinated Mark for several decades. Her sympathetic but probing essay on Bombay prostitutes, from which this picture comes, rightly won her international acclaim. A viewer cannot help but be moved by this picture.

IAMES NACHTWEY

BORN Syracuse, NY, USA, 1948 **PHOTOJOURNALIST**

One of America's leading photojournalists, who has twice won the World Press Photo. He originally studied art and political science. Self taught, he started out as a newspaper photographer in New Mexico, and in 1980 moved to New York and began his career as a freelancer. He has devoted himself to covering wars, conflicts and social issues worldwide. particularly in Central America, the Middle East, Chechnya and Africa. Winner of the Robert Capa Gold Medal four times. He has been a contract photographer with Time magazine since 1984 and a member of Magnum since 1986.

KEY BOOK Deeds of War (1989)

James Nachtwey has often spoken of how the Vietnam War both shaped his political sensibility and opened his eyes to the power of photography. Still pictures from this confused and doomed conflict played a significant role in turning public opinion

against American involvement in Vietnam. Moreover, the conflict was far from clear cut; there were no definite 'good guys' and 'bad guys' and military and civilians were implicated together. This sense of ambiguity shaped Nachtwey's approach to covering conflicts. He does not take sides, nor is he particularly interested in the grand strategy, war in general or what he refers to as 'history with a capital H'. His pictures zoom in on terrible moments and random acts of indiscriminate violence that conflict produces time and time again. He gets very close to the action - as close as Don McCullin or Robert Capa and his pictures have that same visceral quality where the viewer is transported right into battle. Throughout his long and distinguished career he has always been compelled to cover civil wars, such as Rwanda and Nicaragua, where the violence, confusion and uncertainty is at its most intense. War for him is about the tragedy of the individual, the single man, the family. Photographically, like most of his Magnum colleagues, Nachtwey prefers to shoot in black and white and his news pictures have a depth and tonal range that is normally associated with portrait photography. This is particularly evident in the quite gruesome World Press Photo Winner (1995) of a mutilated Rwandan. scarred by his own tribe.

Hutu Man (1994)

A deeply upsetting picture taken during the appalling civil war in Rwanda. This man's face was slashed by his own people, who suspected him of being an informant for the other side. War for Nachtwey has always been about the tragedy of the individual and random acts of indiscriminate violence.

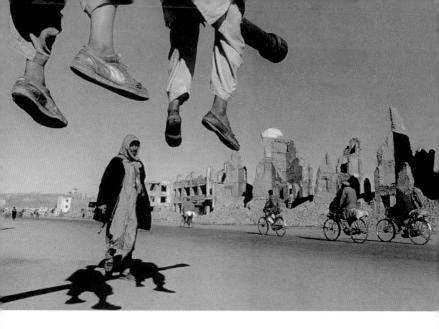

[Left] Afghanistan (1996)

This is a country that Nachtwey knows better than any other Western photographer and which he has returned to time and time again. An almost perfect picture that tells the story of a city devastated by war, but does so in an arresting and gripping way.

[Below] Belfast, Northern Ireland (1981)

This image was taken during the most bloody period of a complex and seemingly unremitting civil war. Note the contrast between the almost balletic, graceful movement of the fire bombers and their violent actions.

HELMUT NEWTON

BORN Berlin, Germany, 1920 DIED Los Angeles, USA, 2004 FASHION/PORTRAIT PHOTOGRAPHER

One of photography's most famous and controversial figures. Originally trained with Yva, a Berlin photographer who specialized in fashion, portrait and nudes. Nazi persecution forced him to leave his homeland and he first settled in Australia in 1940 but later moved to Paris and Monte Carlo where he still resides. First started working for British Voque in 1956, and has been one of the most prolific fashion photographers of all time. Peaked in the late 1960s and 1970s when became a celebrity in his own right. As well as fashion, has taken many portraits of key twentieth-century figures. Has also published dozens of books and been exhibited worldwide.

KEY BOOK The Best of Helmut Newton (1996)

Everyone has an opinion on Helmut Newton. To some, he is a genius who elevated fashion photography into new realms of art; to others, he is a womanhater whose pictures have transgressed the boundaries of acceptability. Newton first achieved notoriety in the late 1960s when he started to incorporate elements of sadomasochism, lesbianism and voyeurism into his fashion pictures. Women were photographed in provocative poses, seeminaly unaware of the camera, caught in post-coital slump or prowling vast hotel rooms coiled with sexual desire. The models (nearly always women) are tall and strong with perfect whiteskinned physiques - the prototypes for the 1980s super-models. The scenarios he concocted reflected his own pent-up obsessions, but not surprisinally, some found the work degrading to women. Today, the images do not seem quite so shocking and that is down to Newton's influence and changing times. What was once politically incorrect is now porno chic. He has been copied so many times that he is rightly somewhat guarded about some of today's 'hotshot' fashion photographers. Newton realized from the beginning that the more ambiguity he builds into his pictures, whereby the viewer is never quite sure how to respond to the scene presented, the greater staying power they have. He is always challenging us with his images. sometimes mocking us, yet always with style and panache. He is also technically brilliant, a fact that is often overlooked due to the content of the pictures; yet the way he lights, composes and frames a photograph is a lesson in itself. There is no such thing as a Newton photograph that can be ignored.

The Shoe for Walter Steiger (1983)
In Newton's pictures everything has some kind of sexual connotation. Even a relatively straightforward picture of a shoe is laden with undertones of foot fetishism and domination.

[Left] French Vogue, Paris (1979)

These sexual games are taking place in an opulent hotel corridor - Newton's favourite location - and the picture is in turn alluring but also somewhat seedy. The couple are also sexually ambivalent which heightens the mystery.

[Below] Le Temps des Joyaux (1979)

A classic Newton shot. The woman may at first glance appear passive but look closer and it becomes obvious that she is very much in control while the man is just faithfully carrying out her instructions. There are also elements of voyeurism in this photograph.

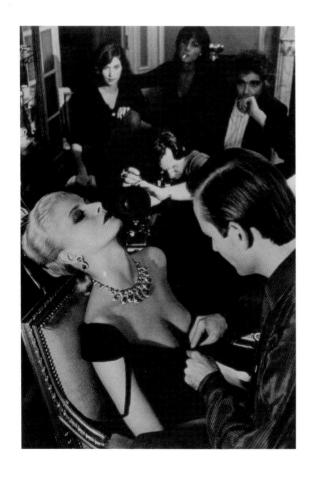

NORMAN PARKINSON

BORN London, UK, 1913 **DIED** Singapore, 1990 **FASHION, COMMERCIAL** AND EDITORIAL

One of the century's most famous fashion photographers who carefully cultivated the image of an eccentric British aristocrat. After a public school education, apprenticed in 1931 to a court and society photographer. From there got his first assignments for Harpers Bazaar, where he built up a steady reputation for street-influenced fashion photography and location shooting. Freelanced for some fifty years, working for Vogue, Queen, and Town & Country. A man of lavish tastes, his lifestyle was funded by lucrative advertising work and celebrity portraits. Was one of the first photographers to use a Hasselblad and pioneered the use of telephoto and wideangle lenses.

KEY BOOK Parkinson Photographs 1935-90 (1994)

Fashion is a capricious business and the stars of today can instantly become tomorrow's has-beens. Norman Parkinson certainly made his mark. An imposing

1.95 m (6 ft 5 in) tall, for some fifty years he was an integral part of the fashion world. His staying power is a testament both to his photography and personality. In his early career, Parkinson was a moderately successful studio photographer. but it was only once he took his camera outdoors that he found his element. Up until Parkinson, fashion photography had been stilted, with the model often looking mannequin-like as she copied classical poses under rigorous studio lights. That would not do for Parkinson. He took the models outside and put them in real places in real situations. As he said: 'My women went shopping, drove cars, had children and kicked the dog.' He also loved travelling (studio work bored him) and this type of 'realist' photography allowed him to combine the two. Today, having a model in an exotic location captured in a blur of movement is standard practice. but it was Parkinson who was one of the earliest exponents. His other great asset was self promotion. Like Capa, he fuelled his own myth, knowing that all publicity ultimately leads to more work. While Capa cultivated the persona of the hard-living war photographer, Parkinson marketed himself as the eccentric English gentleman who just took pictures to pass the time. This could not have been further from the truth as Parkinson was also one of the first photographers to make a very good living from his profession.

Art of Travel (1951)

This was taken at a time when flying and travel still had glamorous connotations. The woman seems a little overdressed for her surroundings but overstatement is what fashion is all about. The plane at the forefront of the frame is a clever touch.

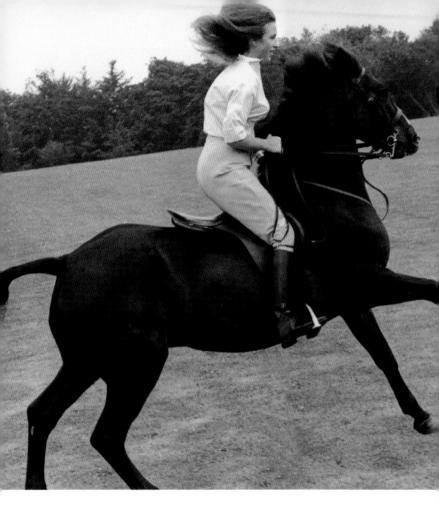

Princess Anne on Horseback (1969) Anne is not the most glamorous of the Royals but Parkinson captures her in her element, as she is an extremely talented rider of Olympian standard. Parkinson revelled in capturing movement.

Greece Lightning (1963) Has there ever been a better location fashion photographer? The model is posed to resemble a dying heroine in a Greek tragedy, albeit a very well-dressed one. With some of Parkinson's pictures the viewer is never sure how seriously to take it all.

GORDON PARKS

BORN Fort Scott, Kansas, USA, 1912 DIED New York, USA, 2006 PHOTOJOURNALIST, FASHION, AND PORTRAIT PHOTOGRAPHER

Most famous as director of the 1971 film *Shaft*, Parks' career began in 1937 when he bought his first camera in a pawnshop. While working as a fashion photographer in Chicago, in his spare time Parks – who had grown up in abject poverty – documented life in the city's slums, and in 1942 he went to work at the Farm Security Administration. He later shot for *Life* and *Vogue*, and in 2002 he was inducted into the International Photography Hall of Fame.

KEY BOOK Born Black (1970)

Ella Watson stands before the Stars and Stripes, her tired eyes and torn dress as eloquent as her unashamed gaze and upright pose. The title, 'American Gothic, Washington D.C.', is – like the carefully positioned broom and mop – a reference to Grant Woods' famous painting, but also to the racial prejudice of America in 1942. This was the year that Gordon Parks began working for the Farm Security Administration (FSA), joining other photographic luminaries such as Walker

Evans and Dorothea Lange. The FSA was set up as part of Roosevelt's New Deal to help alleviate rural poverty during the Depression. Its Information Division was meant to promote sympathy for the plight of farmers and popular support for government intervention - but one of the first images Parks produced was this bitingly critical shot of a woman working at the FSA's own offices in Washington (a city that Parks found suffused with racism). The image was too close to the bone for Parks' boss Roy Stryker, who said it would get all his photographers fired if it was published; nevertheless he advised Parks to keep working with Ella Watson, and the resulting images of her at home with her family display compositional brilliance, enormous compassion, and the talent for narrative essential to in-depth reportage. In his subsequent twenty-year career at Life magazine, Parks put this talent to great use, producing famous stories on the fight for civil rights (especially noteworthy was his intimate study of Malcolm X, and his work with revolutionary group the Black Panthers), and on cultural heroes like Muhammad Ali and Duke Ellinaton. Despite being turned down - because of his race – by Harper's Bazaar, he also had a lengthy and distinguished career as a fashion photographer. On the topic of his varied career. Parks remarked: 'I have loved all the various aspects of photography. They kept me alive and in pursuit of something special.

American Gothic, Washington, D.C. (1942)
The penetrating and reproachful gaze of Ella Watson, cleaning lady at the Farm Security Administration offices in Washington where Gordon Parks worked.

MARTIN PARR

BORN Epsom, UK, 1952 **PHOTOJOURNALIST**

One of Britain's most successful and prolific photographers. Has also made several documentaries with the BBC and his work has been widely exhibited in Europe and North America. Heavily involved in photographic education, he is a seasoned lecturer and has taught at several colleges in the UK. Has also ventured into corporate and advertising photography, and has shot TV commercials

KEY BOOKS Bad Weather (1982); The Last Resort (1986); Cost of Living (1989); Small World (1995); Common Sense (1999)

Martin Parr has said: 'you either get my photography or you don't.' Well, a lot of people don't. They dismiss his lurid and unflattering close-ups of the worst aspects of consumerism as Parr merely sneering at those who do not share his good

outside his native England, interestingly - who argue that he is a humanist in the best Magnum tradition. Since the early 1980s, Parr, through his highly distinctive colour photography and almost surreal compositional sense, has been commentating on the homogenization of mass culture. Everything here is reduced to its same basic level and we are basically what we consume. Parr has created an international visual language that transcends national boundaries, and where a hamburger, for example, has as much currency in Helsinki or Moscow as it does in New York. In the 1980s his seminal work The Last Resort, which depicted a frankly squalid seaside resort just outside Liverpool, England, was regarded in those politically correct times as unflinching to the point of being reactionary. Parr defended the work, saying that his critics, by and large from the middle classes, were just confirming their own prejudices. Since then, while he has not quite mellowed, there is certainly more humour in his work, with Parr relying more on the use of a macro lens to convey the sheer awfulness of those tacky souvenirs and sugar-encrusted doughnuts that we all come across from time to time, but choose on the whole to ignore. Parr not only acknowledges their presence but, for better or worse, celebrates their existence.

taste. However, there are others - mainly

From A to B: Tales of Modern Motoring (1994). It is all very English and all very ordinary: a family on a day out taking delight in the simple pleasures of an ice-cream, which they appear to be enjoying more than each other's company. The picture is very funny, but also a little sad.

Europe. Ooh La La (1997)

The somewhat sickly and artificial are given the Martin Parr treatment in this typically surreal composition. In his earlier career Parr kept more of a distance between himself and his subjects, but he now favours using extreme close up, so the audience can hardly fail to miss his cynical take on modern consumption.

RANKIN

BORN Glasgow, Scotland, 1966 FASHION/PORTRAIT PHOTOGRAPHER

One of Britain's most high-profile and prolific image makers of the 1990s. In 1991, co-founded the ultra-trendy style magazine, Dazed&Confused, which placed him at the forefront of British creative culture, both as a commentator and barometer. This led to commissions from a multitude of publications; record companies (including album covers for the Spice Girls and U2); and commercial assignments. Clients include Diesel. British Airways and Firetrap. Work has also been exhibited in London and Milan. He is a keen supporter of student photography, and has also hosted photography workshops for former street children in Brazil

KEY BOOK Nudes (1999)

Rankin compares making a film to telling a story, and photography to telling a joke. His pictures therefore are known for their strong punchlines, but the humour is not there just to amuse the viewer but also to educate. For instance, in his fashion pictures he questions the ethics of the industry itself. There is one photograph of a very thin model gorging on a huge bar of chocolate which examines the link between fashion and anorexia He also featured, on an early cover of Dazed&Confused, a model cryina her eyes out, highlighting the fact that although on the outside it may be a glamorous industry, it is also exploitative, making beautiful women have low self-esteem. His portraiture tends to be more conventional. with Rankin equally adept in colour and black and white and favouring strong eve contact, few props, ring flash and closely cropped pictures but always with a little twist to draw in the viewer. He believes that the best portraits are the result of a collaboration between the photographer and the subject. The stars trust his judgment and he values their input. There are not a lot of tricks to his photography: it is solid and not too stylized but remarkably consistent. He also has the ability to make the stars always look good – a necessary prerequisite for all celebrity photographers - but also human. These pictures are not huge production numbers but guite intimate affairs fuelled by Rankin's enthusiasm and infectious sense of humour. Still in his early thirties, you know he will be around for a long time to come.

Richard Ashcroft (1997/8)

The lead singer of the now disbanded cult band The Verve. This is one of the photographer's favourite portraits and it shows the singer as quite vulnerable and almost feline, quite at odds with his more moody public persona.

[Left] Feeling Hungry (1995)

One of the photographer's most famous pictures. This image is a take on the fashion industry and its obsession with using very thin models who border on anorexia. Note how the fabric is stapled to the girl's wrists, again to accentuate her slenderness.

[Below] Dead Fashionable (1995)

A clever title and play on words, with dead meaning the obvious as well as the more slang 'very much so'. The photographer here is making the point that the fashion industry will do almost anything to remain fashionable.

ELI REED

BORN Linden, NJ, USA, 1946 PHOTOJOURNALIST

One of the world's leading photojournalists who has covered conflicts in Central America, Zaire and the Middle East (in particular Beirut), but is best known for his unflinching photographs of the African-American experience. Started taking pictures at a very young age. His work has appeared in all the world's leading publications including Time, The New York Times and The National Geographic, and he is a member of Magnum. Also a talented film maker, writer and director; made a seminal film on Detroit gangs. Winner of numerous awards including the Leica Medal of Excellence and World Press Photo.

KEY BOOK Black in America (1997)

In the foreword to *Black in America*, Eli Reed writes that his book is 'about spirit and substance, about successes and failures and social intercourse between

the races, particularly blacks and whites . . . the situation is not good but I am an optimist'. He is also an outstanding photographer who combines technical proficiency with a deep humanity; the eye and hand working in perfect coordination with the heart. The last thirty years have been particularly troubled for African-Americans: unabated racism, inner-city deprivation, violence, crack, homelessness, the Los Angeles riots and poor education opportunities. In some respects it is as if the civil rights movement never happened. Reed is angry at what he sees; his pictures are there to enrage the viewer, to shake them out of their complacency. Reed is close to his subject. He admits that he is not necessarily 'objective', but why should he be? His camera is there to tell the truth. Reed is the war photographer who has come home to report on the battles that are happening in his back yard. Yet Reed is so much more than a mere bringer of bad tidings. To be an African-American is not just one almighty struggle. Reed is an optimist, and many of his photographs portray moments of great joy, serenity and beauty. There are pictures of weddings, proms, church gatherings, playgrounds, even black rodeos; singers, lawyers, athletes, soldiers and political activists that hint that maybe, sooner rather than later the States really will be United.

The Palestinian refugee camps of Sabra and Shatila taken in 1982 during the Israeli occupation of Southern Lebanon. Although best known for his photographs of the African-American experience, Reed has made many visits to the Middle East.

[Above] Housing Project, San Francisco, California (1984) This is one of Reed's most famous images and encapsulates a particularly hard period in African-American history, when hard drugs in the form of crack cocaine began to take a grip on the inner cities and the Republican Government ignored this new underclass.

[Below] Harlem Rodeo, New York City (1995)
Reed's mission is to present the complete experience of what it means to be black in America, therefore many of his images deal with lighter subjects such as this rodeo in Harlem, which is a long way away from the vast open plains of the Wild West.

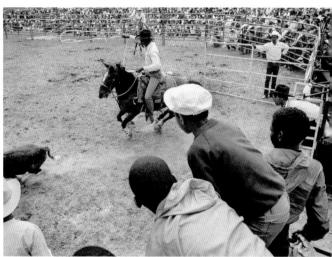

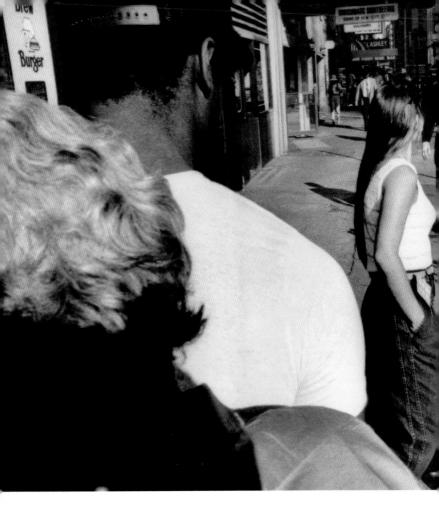

Seventh Avenue, New York City (1986)
A shot leaden with irony. Ronald Reagan, the man who dominated American politics in the 1980s, saw himself as a man of the people but really he was anything but. The composition is wonderfully surreal.

MARC RIBOUD

BORN France, 1923 PHOTOJOURNALIST

One of the France's most famous post-war photojournalists, second only perhaps to Henri Cartier-Bresson who was his early mentor. Engineer in his early career and fought for the French Resistance in the Second World War. Started taking pictures seriously after the war, and like all the leading photojournalists of the day was an avid Leica user, Impressed Robert Capa with an essay on men painting the Eiffel Tower, and by 1953 joined Magnum of which he was a member until 1980. His work is most closely associated with the East, in particular Vietnam, Cambodia and most memorably China.

KEY BOOK Forty Years of Photography in China (1997)

'For me photography is not an intellectual process. It is a visual one.' This has been the ethos of Marc Riboud's fifty-year career. He has never aspired to be an artist and is disparaging of photographers who sees

themselves in those terms. Riboud has always favoured light equipment because it allows him to get closer to his subject; and more importantly it means he can take pictures instinctively without thinking about what he is doing and why. He simply photographs what interests him. and that tends to be the exotic and the alien. Riboud's career is closely identified with China, Cambodia and Vietnam. The allure of China for him is the vastness of the country and its population, the intensity, and the sudden shifts in the political and cultural climate. Riboud is very much an outsider: his pictures do not try to 'understand' China and he admits he does not speak a word of the local languages. The images therefore are tantalizing glances, masterfully composed mini essays, that shed a little light on an impenetrable society. Riboud is the Western observer, the enlightened cultural tourist who is going in search of answers. Riboud is also attracted to the spiritualism of the East: the solitude and detachment that has parallels with professional photography. One of his books is subtitled The Serenity of Buddhism and there is always a calmness about Riboud's photographs. They are pictures of a person quietly going about his business, but still repeatedly coming up with the goods.

Anti-Vietnam Demo (1968)

One of the most famous photographs of the 1960s, with the flower child confronting the soldiers with the only weapon at her disposal. The image told the story of a divided nation and helped sway public opinion even further against American involvement in the war in Vietnam.

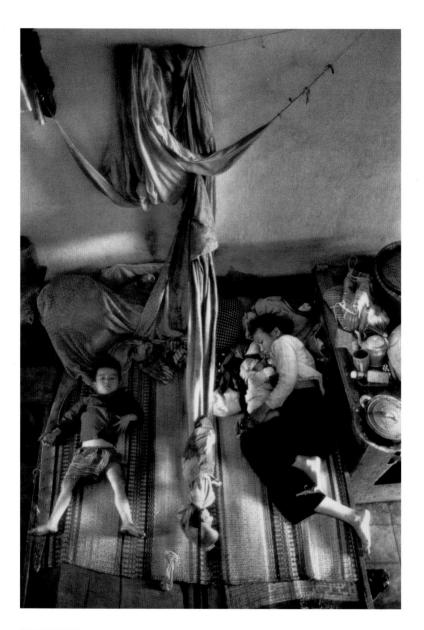

[Left] Refugees in Hue, Vietnam (1968)

These are refugees from the war taking sanctuary in a church. Once again we see the innocent and the helpless caught up in a conflict that they do not understand, but which has nevertheless destroyed them. The boy gazing at the camera could symbolise either hope or despair.

[Below] Angkor Wat (1969)

A delightful photograph that conveys Riboud's fascination with the mysteries of the East and in particular what he calls the Serenity of Buddhism. This picture works on many levels – as a travel photograph, as a reportage picture, but also as a very powerful portrait.

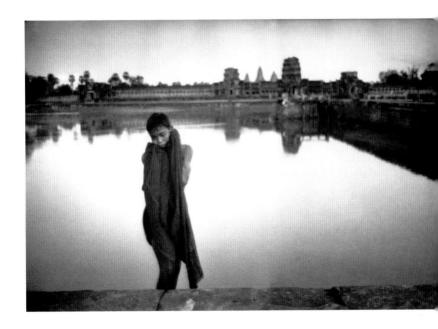

HERB RITTS

BORN Los Angeles, USA, 1952 DIED Los Angeles, USA, 2002 CELEBRITY/FASHION PHOTOGRAPHER

Was one of the world's most successful photographers snce the mid-1980s. In 1979 got his big break by taking pictures of a friend, the actor Richard Gere, a comparative unknown at the time, which led to more sessions with many other early 1980s stars. Later took on the mantle of Hollywood's favourite photographer, despite having no formal training. Very much associated with California in terms of lifestyle, attitude and subject matter, although he did publish a book on Africa (1994). Work has appeared in all of the world's most high-profile magazines, including Voque and Vanity Fair. Also worked with designers Armani and Versace.

KEY BOOK Notorious (1992)

It is very hard to talk about the career of Herb Ritts without continually referring back to his equally famous contemporary, Annie

Leibovitz. They share common ground over subject matter and client, namely Vanity Fair, and wealth. Also, both have been accused of confusing celebrity with substance, but in style they are vastly different. Ritts' images are predominantly black and white, usually set against a plain backdrop, highly graphic, beautifully lit. uncluttered and quite timeless. His influences are obvious: Avedon Penn and, going back even further, Horst and Hoyningen-Heune, but he is more than just a highly skilled revivalist, Ritts' pictures are technically perfect and, coming from a laid-back Californian sensibility, is it any wonder that he has been accused of lacking soul? Yet his critics are missing the point. For Ritts' portraiture is an exaggerated reality; it is about making the person look as good as they possibly can; keeping everything very simple and relying on the old-fashioned virtues of composition and contrast between light and shadow. His pictures of Madonna taken in the late 1980s are particularly memorable. and this was at a time when she was the biggest star in the world, bar none. It may seem something of a paradox for a portrait photographer to be more interested in the aesthetic of the picture, than in the personality of his sitter, but Ritts manages to pull it off. The stars must like it, because for the duration of his career they kept coming back for more.

Liv Tyler (1997)

The rising young actress is looking away from the camera as our attention is captured by the highly decorative body painting on her arms. Ritts is a supreme stylist and always gives his subjects the chance to shine.

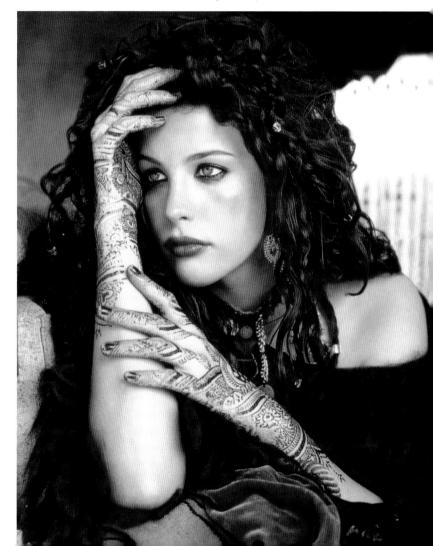

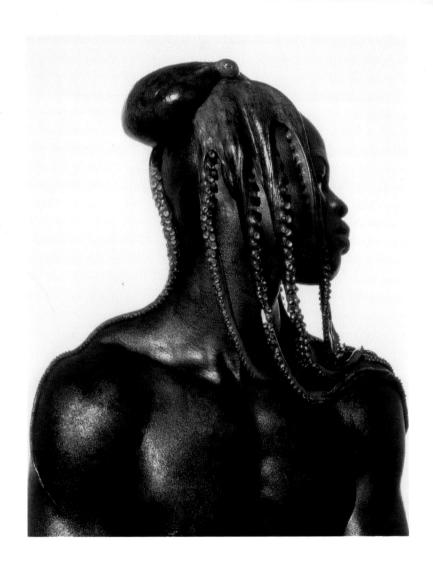

[Left] Djimon (with Octopus)

A strange picture which leaves the viewer feeling a little uneasy. Is it a joke? Or is something profound being revealed? Either way it is certainly an imaginative way of photographing someone.

[Below] Madonna, True Blue (1986)

Madonna is possibly the icon of the 1980s and Ritts has photographed her repeatedly since the material girl first

photographed her repeatedly since the material girl first stormed the charts. It is a neat statement of opposing textures of vulnerable, bare flesh and coarse leather – the curve of her neck is also attractive.

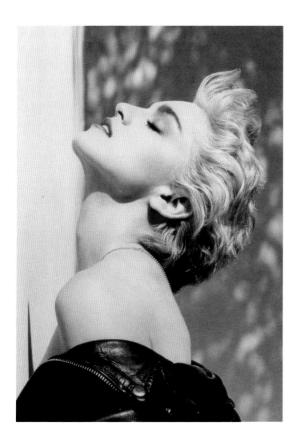

ALEXANDER RODCHENKO

BORN St Petersburg, Russia, 1891 DIED Moscow, USSR, 1956 FINE-ART PHOTOGRAPHER

Russia's pre-eminent artist between the two World Wars. Today, his images are highly valued and sell for hundreds of thousands of dollars. Originally worked as a sculptor, painter and araphic artist. First artistic efforts were montages featuring other people's images but didn't start working with a camera himself until the mid-1920s. One of the pioneers of the 'constructivist movement': a non-representational, linear, abstract style of art that places form above content by using bold and oblique perspectives. By the end of the decade, the avant-aarde had fallen out of fashion and from the 1930s onwards he took more reportage-style pictures for the propaganda periodical USSR in Construction.

KEY BOOK The New Moscow (1998)

Prior to Rodchenko, buildings, objects and people had always been photographed from the waist level, with the picture taker looking downwards into the viewfinder. Rodchenko felt that this type of representation was too static and did not reflect the way we see the world. He believed that photography should mirror the movement of the eye, which absorbs detail from a variety of perspectives and from a multitude of anales. Thus Rodchenko took pictures from low and high viewpoints and used extreme close-ups. Objects which hitherto appeared prosaic were now depicted from all sides and were thus seen in a new light. In his pictures, everything has a purpose. His critics, however, found his eccentric perspective no more than trickery. For Rodchenko, it was an instinctive response to the world around him that he saw in highly graphic and linear terms; where everything, if you looked at it hard enough, eventually meraed. His most famous photograph, 'Stairs', taken in 1930, has all these elements: the oblique perspective, the lines of the stairs, the use of shadow and the ascending woman holding the child are all part of a 'constructed' world. Nevertheless, it is a real world that is shifting and changing, in much the same way as Rodchenko's perspectives. It was Rodchenko's and our good fortune that his new vision coincided with the rise of the small, portable Leica. This classic camera liberated many photographers, but mainly photojournalists. Rodchenko should also be applauded in bringing this camera into the realms of fine art, enabling him to take such timeless pictures.

Girl with Leica (1933)

The interplay between light and shadow is what gives this image its undeniable beauty and power. Rodchenko was also a great fan of the new 35mm format for taking pictures and he wanted the world to know about his discovery.

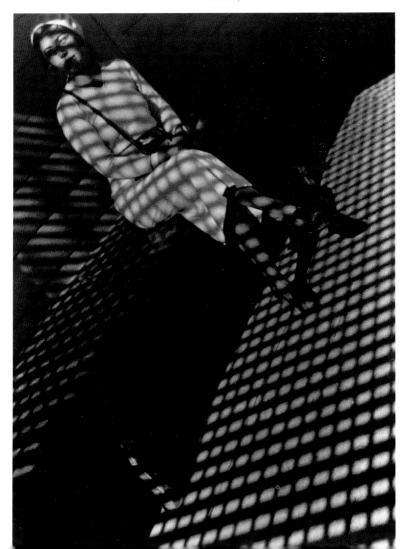

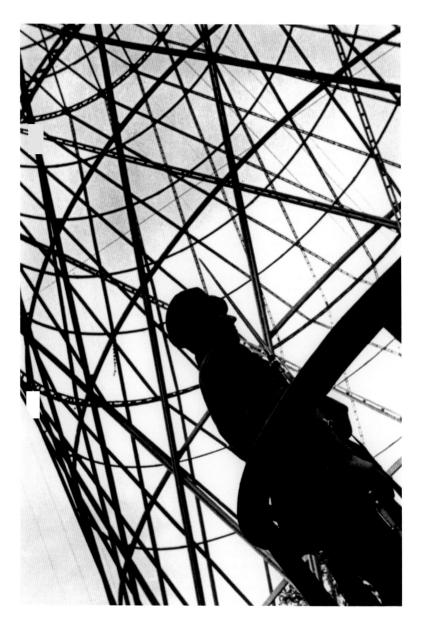

[Left] Sentry of the Shukov Tower (1929) Like many photographers of the day Rodchenko was fascinated with the constructed world - the steel, the brick and the metal which dominated the urban environment. Here he adopts a low vantage point.

[Below] To the Demonstration (1932) Rodchenko was one of the pioneers of using photography to reflect the movement of the human eye, hence his fondness for oblique and unusual perspectives. Taken from such an angle, the demonstration takes on the mantle of a heroic struggle.

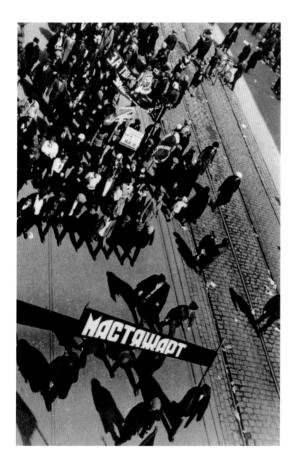

GEORGE RODGER

BORN Hale, UK, 1908 DIED Smarden, Kent, UK, 1995 **PHOTOJOURNALIST**

One of the founders of Magnum. Took up photography after a stint in the Merchant Navy in the late 1920s. Got a job as a BBC photographer and then started freelancing for Life and the Black Star agency. During the Second World War was the only British freelance photographer and took pictures of the Blitz and the liberation of the concentration camps. After the war, travelled extensively in Asia and Africa and shot famous essay on the Nuba tribe. By the 1950s, working more in corporate areas and film, and for The National Geographic.

KEY BOOKS Humanity and Inhumanity (1994)

Along with Bert Hardy and Don McCullin, George Rodger is one of a trio of outstanding British photojournalists of the twentieth century. He was not as

flamboyant as Robert Capa, both as a man or photographer; nor quite as artistic as Henri Cartier-Bresson and therefore has never been spoken of in such revered terms as his two Magnum colleagues, but Rodger is at last being rightly acclaimed for his simple, clear and beautifully made photographs. He was never very interested in the mechanics of the medium, but that worked to his advantage. The pictures are not particularly stylish or dramatic, as Capa's for instance, but they are masterful examples of describing important events highly effectively. He saw the photographer's role as no more than a witness, the person who sees and records. In Rodger's pictures there is always a curiosity about situations and people: a desire to find out more, but always with the audience in mind. He does not take pictures for personal alory; free of eao or artistic pretension, he quietly goes about his business photographing on instinct. It is a paradox that this unassuming human being shed light on mankind's darkest hours, and his pictures of the liberation of the concentration camps are some of the most harrowing of the twentieth century. Not surprisingly, Rodger afterwards lost faith in Western civilization and headed towards Asia and Africa. There he met up with the Nuban wrestlers, resulting in an iconic image of a giant of a man sitting on a colleague's shoulder.

Sudan, The Nubas (1949)
Rodger's most famous photograph. The Nuba pride themselves on their ability at wrestling, their tribal sport. They are powdered in wood ash so that they can get a grip on each other. Here the champion is carried shoulder high.

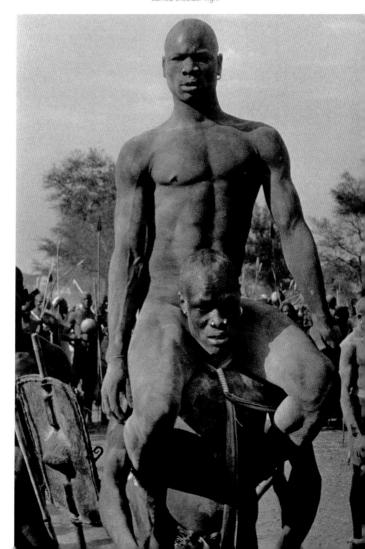

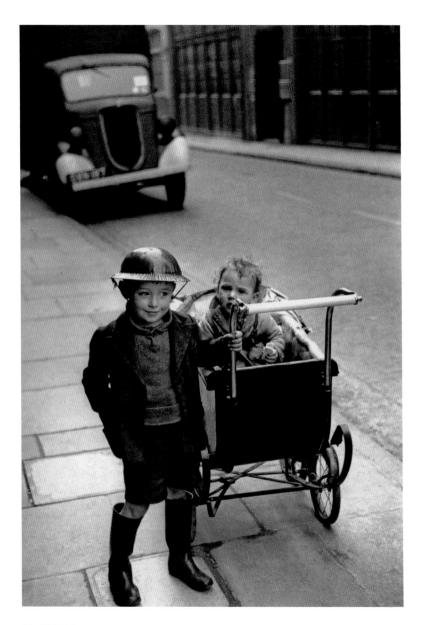

[Left] Life in London During the Blitz (1940) In the East End of London during the Blitz bombing by the Germans, steel helmets were issued. Those who could get them, wore them.

[Below] Western Desert, WWII (1941) Graves of the crew of a British bomber shot down in June 1941. The inscription reads: 'Here lies an unknown British lieutenant who died in the air war,' written by the German enemy.

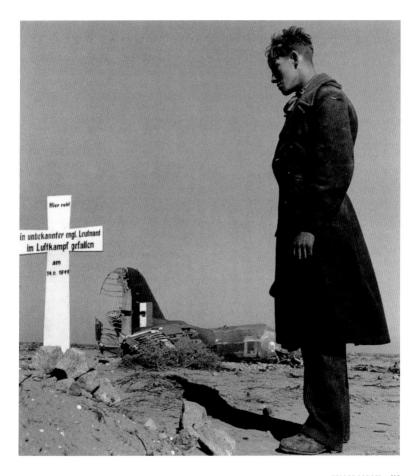

WILLY RONIS

BORN Paris, France, 1910 DIED Paris, France, 2009 DOCUMENTARY PHOTOGRAPHER

The son of east-European Jewish immigrés, Ronis grew up in a family where music and photography were staple fare: his mother taught piano and his father ran a portrait studio. Gifted in both disciplines, Ronis renounced music in favour of work in the studio because of his father's illness. At the latter's death in 1936. Ronis found work as a photojournalist, like his friend Robert Capa. Fleeing Paris after the occupation, he spent much of the war in southern France where he met his future wife, the painter Marie-Anne Lansiaux, and her infant son Vincent. Returning to Paris in 1945, he resumed his career, initially with the Rapho agency. His work won international acclaim and was shown at the Museum of Modern Art, New York in 1951. His political views led to him working independently from 1954, and after living in the South of France from 1972, he returned to Paris in 1983.

KEY BOOK Willy Ronis: Photographs 1926–1995 (1995)

Ronis began to make remarkable photographs in 1926, and although it took him many years to accept this medium as his best route to self-expression, he has managed to create a substantial and distinctive œuvre throughout a long and sometimes difficult career. Music helped him develop an acute sense of composition, and an early fascination with Flemish art is evident in many of his street scenes, which recall a Bruegel painting in their animation and apparent orchestration. One of the most interesting of the French humanists. Ronis was able to translate the movement's fascination with the lives of ordinary French people into images of lasting significance, such as 'Avenue Simon-Bolivar, Paris' (1950). This is particularly clear in his study of the working-class Parisian quarter Belleville-Menilmontant. Ronis used the full palette of greys available in black and white film, and the mobility of the hand-held camera to capture the vibrancy of street life, its lyricism as well as its occasional melancholy. In his best work, Ronis allies a fine compositional sense (initially with the square-format Rolleiflex, and from 1954 almost exclusively in 35 mm) with emotion and a profound sensitivity towards his subjects. For many of his most popular pictures - 'Le Nu Provencal' (1949). 'Vincent the Aeromodeller' (1954) - his subjects were his wife and adoptive son. His political commitment may have made Ronis's life more difficult in the 1950s.

La Columne de Juillet (1957)
The lovers gaze out at the Paris skyline at the Place de la Bastille. This picture demonstrates Ronis's fine compositional sense allied with emotion and a sensitivity towards his subjects.

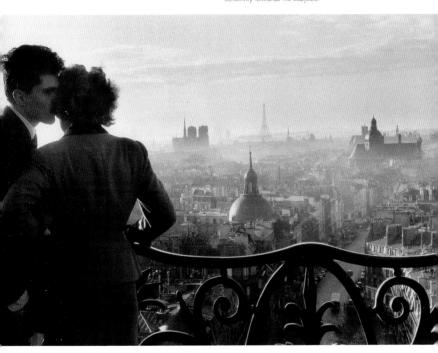

but it also produced an important body of work on working conditions and strikes in French industry. Yet Ronis also excelled in other areas, working successfully as a fashion photographer for *Vogue* and *Jardin des Modes*, and on advertising, industrial and commercial projects.

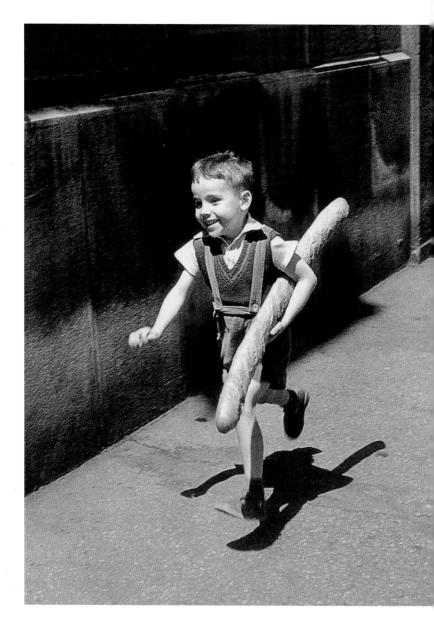

[Left] Le Petit Parisien(1952)

The purchasing of the morning baguette is something of a ritual in France and looking at this picture, you can almost hear the patter of this small boy's feet as he rushes home under instruction from his mother.

[Below] Janvier (1935)

An early landscape from Ronis. In his later career Ronis was very much associated with urban settings, but this photograph shows that he was equally adept away from his favoured streets of Paris

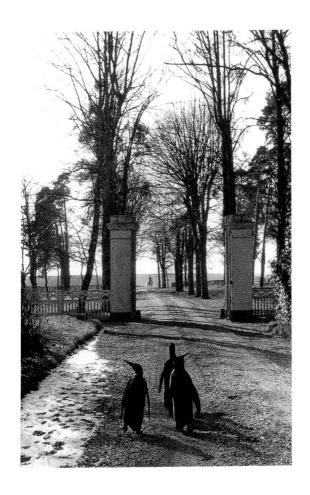

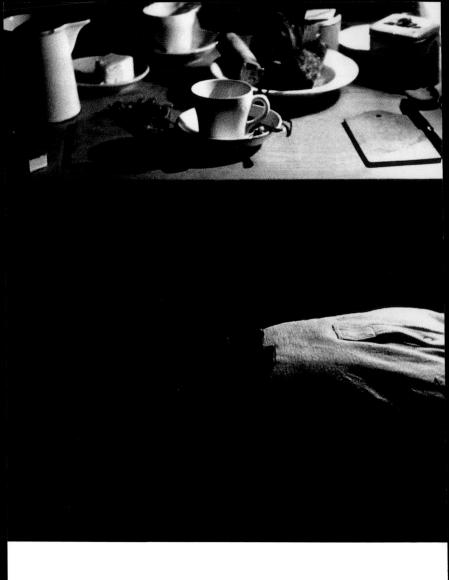

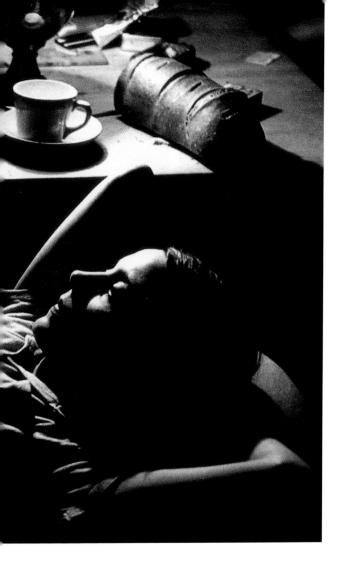

Le Repos du Cirque Pinder en Province (1955) An elegant and understated image of a circus performer taking a well-deserved rest.

SEBASTIAO SALGADO

BORN Aimorés, Brazil, 1944 PHOTOJOURNALIST

Originally trained as an economist and moved to Paris in the late 1960s to continue his studies. In the early 1970s. while working for the International Coffee Organization, began to take an interest in photography. Self taught, this new-found passion became his life's vocation and he soon found a niche in documenting political, economic and environmental changes in acutely human terms. Has covered many of the worst conflicts of the past 25 years, but is best known for his opus Workers (1993). a huge project on manual labour from around the world. One of the most important post-war photography books.

KEY BOOK Workers (1993)

As the chapter closes on the twentieth century, traditional methods of labour and production are being constantly superseded by new technology. Salgado's Workers documents all this and more; but above all it is a tribute to the human condition and a homage to labour. From the gold mines in Brazil to the oil rias of the Gulf, from the Channel Tunnel to an Indonesian sulphur mine, Salgado is there, recording in 35 mm the drama, the despair, but above all else, the dignity of the working man and woman. Up to the time that Workers was published, Salgado was a highly respected photojournalist, but this epic project propelled him into another dimension entirely. Salgado's pictures are equally at home on a gallery wall as they are in the pages of a book or magazine. which is one sign of a great photographer. He also has a natural affinity with his subjects, without the sense that he is either being patronizing or deifying those he photographs. He is sympathetic – after all he is championing their cause - yet his vision is never blinkered. No matter how much emotion is being invested in the taking and getting of the pictures, the final result is often quite detached and objective. Salgado also has a superb eve and is equally adept at photographing huge groups of people, individuals, landscapes, or heavy industry in that same probing, truthful way. In Brazil he is regarded almost as a saint, as he is by many of his subjects.

Serra Pelanda, Brazil (1986)

This gold mine looks like a human beehive as 50,000 men covered in mud struggle daily across this man-made hole the size of a football pitch. It is remarkable to think that this picture was taken at the tail end of the twentieh century, when it could easily be a scene from the Middle Ages.

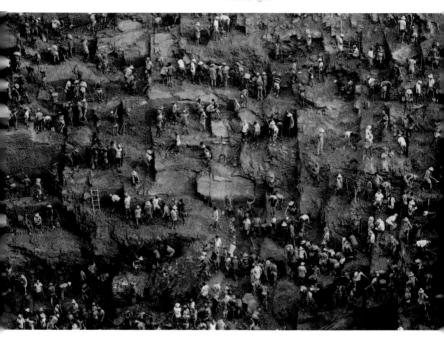

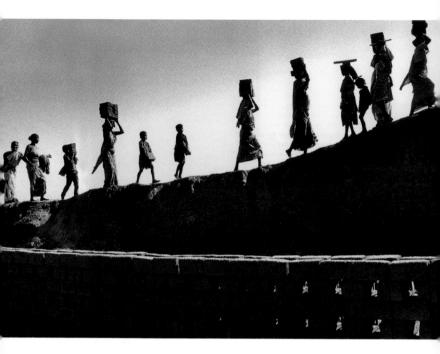

Endangered Tribes, Bihar, India (1997) This picture forms part of a massive long-term project on people being dispossessed of their land in the developing world. Our eye is drawn to the contrast between the man made and natural landscape and the women and children moving ant-like across the horizon.

The Margin of Life, Sudan (1985) A stark and poignant image illustrating the plight of this tragic country that is blighted by one natural disaster after another.

AUGUST SANDER

BORN Herdorf, Germany, 1876 DIED Cologne, 1964 PORTRAITIST AND LANDSCAPE PHOTOGRAPHER

August Sander set up his own studio in Cologne in 1910. There he began his project 'People of the Twentieth Century', in which he hoped to record the faces of 600 German types. 60 of these images were published as Face of our Time in 1929, but when the Nazis took power the project was curtailed, his son killed, and his book confiscated. The house where Sander lived in Cologne was bombed and destroyed in 1944, although some 600 negatives and prints stored in the basement survived until 1946 when the flat was destroyed by fire.

KEY BOOK Face of our Time (1929)

Three young men stand on a dirt track in the German countryside. All wear dark suits and carry canes, but there is an evolutionary progression from the last – with dishevelled hair, cocked hat, and dangling cigarette – to the first, who affects a look of aristocratic hauteur. There can be no doubt that these men, whose feet are still planted in the mud, are peasants, but they are on the road somewhere; like the rest

of Sander's images, this is not a traditional portrait of individual psychology but a document of a changing society. 'Nothing,' Sander wrote, 'is more hateful to me than photography sugarcoated with aimmicks. poses and false effects. Let me speak the truth in all honesty about our age.' As such, his work can be considered part of a 1920s art movement called New Objectivity, which rejected the excesses of Expressionism in favour of a cool, hard look at the realities of society - which in Germany seemed to be on the verge of disintegration. Peasants were moving to the cities en masse where, under the tough conditions of industrial work, or impoverished by economic catastrophe, their ears were opened to the radical politics that threatened to extinguish traditional German culture. Sander incorporated many examples of the old way of life - peasants, herbal doctors, craftsmen - but he also showed representatives of modern capitalism, such as industrialists and revolutionaries. His insistence on social position (his pictures are captioned with vocations, not names) places his work in a dubious ethnographic tradition, and betrays a deeply conservative view of society. However, his sympathetic portrayals of craftsmen suggests a hope that this outmoded way of life might offer a middle path between revolution and the harshness of industrialization - but in the end it was these same middle-classes that voted for Hitler, thus terminating Sander's project.

Young Farmers (1914)
Their feet caked in muck but their faces to the future: these three German farmers could be on the road to metropolitan sophistication.

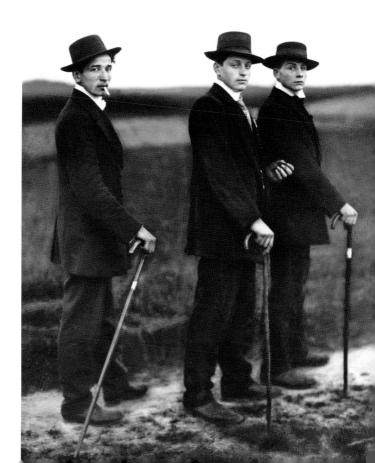

CINDY SHERMAN

BORN Glen Ridge, New Jersey, 1954 FINE-ART PHOTOGRAPHER

A seminal figure on the 1980s art scene, Cindy Sherman rose to international fame in the late 1970s with 'Untitled Film Stills': black-and-white, pseudo 'B'-movie film stills all featuring Sherman commenting on the stereotypical presentation of women through film. She studied for her degree at New York State University in the mid-70s, during which time she was a member of the artistic group 'Hallwalls' along with Robert Longo and Nancy Dwyer. She followed the success of 'Film Stills' with 'History Portraits' in which she playfully recreates well-known historical portrait paintings with herself playing the double role of artist and model. Sherman's work is included in major collections including the Pompidou, Paris; Museum Folkwang, Essen: and Museum of Modern Art. New York.

KEY BOOK Cindy Sherman Retrospective (1997)

Cindy Sherman's novel performance-based photography took the art market by storm in the 1980s. Through her wild transformations and ability to create pure theatre. Sherman

has consistently tapped into the spirit of the times and succeeded in commenting on key issues for society around identity, sexual politics and power, In 'Untitled Film Stills'. Sherman assumes sixty-nine different roles: femme fatale, bored housewife, rebellious adolescent etc, all characters in films that only exist in Sherman's own mind. These stills tease the audience into fleshing out a story-line for them. Sherman is pointedly reminding us of the power of film in engineering social and moral values. Her later series, 'History Portraits', are powerful painting-sized colour prints. In them, Sherman's inspiration shifts from film theory to art history as she dons Italianesaue fabrics, seventeenth-century wias. false noses and breasts, in a concerted effort to invite the viewer to reflect on the constructed and false nature of portrait representations, even at the hands of the great masters. Sherman's recent work, in which she has unusually stepped out of the frame. has taken a much darker turn with disturbing images of contorted female dolls in indecent and sexually violated poses reminiscent of the photo work of surrealist Hans Bellmer. In this work, Sherman moves through and past the surface of female stereotypes into the subconscious and sometimes disturbed aspects of our mind's eye. Her phenomenal success and acknowledgement in the general art world lies in her ability to produce large, very varied bodies of work which shock us into reassessing cultural icons that have become so ingrained in daily life we have actually stopped questioning their purpose.

Untitled (1994)

In this series Sherman takes herself out of the frame and the pictures are even more dark and sinister. Here she is using dolls to illustrate extreme sexuality, exploitation and even abuse. The public reaction to this work was ambivalent.

[Left] Untitled (1990)

'History Portraits' sees Sherman at her most provocative and flamboyant, where she is happy to don wigs and false breasts as she goes about parodying traditional portraiture. The point she appears to be making is that all portraits are constructed and therefore are not necessarily truthful.

[Below] Untitled (1981)

This is part of the 'Film Stills' series where Sherman assumes 69 different roles, all fictional characters, ranging from vamp to rebellious teenager, from bored housewife to victim. Sherman uses film to explore issues around identity and sexual politics.

STEPHEN SHORE

BORN New York, USA, 1947 FINE-ART PHOTOGRAPHER

Shore began his career at the age of 14 when he presented his photographs to Edward Steichen, then head of MoMA's photography department. At 17 he left school to hang out at Andy Warhol's factory, and in 1971 became the second living photographer to have a solo show at the Metropolitan Museum - he was only 24 at the time. The following year he took his first road trip across the USA. His 1998 book, The Nature of Photographs (based on a course he ran at Bard College, where he is Director of the Department of Photography) has become a standard primer.

KEY BOOK American Surfaces (1999)

In 1972 Stephen Shore left his native Manhattan for the first of several road trips across the States. Leaning out of the passenger window, Rollei point-and-shoot in hand, he made the work most closely associated with his name: a series of colour photographs of vernacular roadside architecture (such as diners, motels and gas stations), deserted small-town streets,

portraits of his friends and strangers. and still-lifes composed of disposable or everyday objects. In his own words: 'I was photographing almost every meal l ate, every person l met, every waiter or waitress who served me, every bed I slept in, every toilet I peed in.' Like any tourist, when he got back he took his hundreds of rolls of film to a Kodak store, and exhibited the resulting prints - taped straight to the gallery wall - under the title 'American Surfaces' (they were not published until 1999, when they were collected in a book of the same name). Shore's use of colour and his concern for the mundane was, as in the work of the slightly older William Eggleston, a pioneering development in a largely monochrome photography world. Up to this point, photographers and gallerists had disdained colour as more suited to advertising than the gallery, but now with curator John Szarkowski at the helm of MoMA's photography department - a technicolour revolution occurred. For his next project, Shore - who had beaun his career using 35mm - upgraded to a cumbersome view camera producing 8x10 plates. This was an awkward machine to drag across a continent. and an unexpected departure for the man who virtually invented the 'snapshot aesthetic', but it allowed him to examine his apparently everyday subject matter in unprecedented detail. This kind of intense focus had previously been reserved for

U.S. 10, Post Falls, Idoho (1974)
With his sublime shots of banal situations, Shore
demonstrated that colour was a valid, even essential tool,
by using it to create compositions of mind-boggling
complexity and brilliance.

the grand landscapes of photographers like Ansel Adams: now Shore gave the detritus of pop culture the same dignified treatment, inflating a motel TV set to the monumentality of El Capitan. These images were published in the photobook *Uncommon Places* in 1982. Shore's legacy has had a lasting influence on

a younger generation of photographers such as Martin Parr and Thomas Struth, who have furthered his investigation into empty suburban back streets and garish mass culture. Meanwhile Shore continues to explore the possibilities of the medium, now exclusively using digital cameras for his commercial projects.

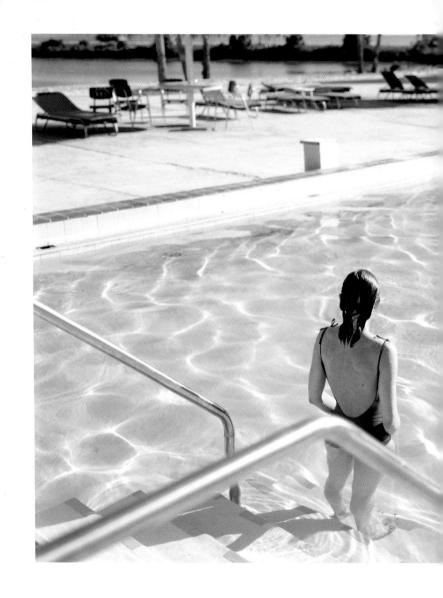

Ginger Shore, Causeway Inn, Tampa, Florida, Nov. 17, 1977 (1977) Angst in paradise, as a lone swimmer contemplates the glossy void of the sunlit pool.

W. EUGENE SMITH

BORN Wichita, Kansas, USA, 1918 DIED Tucson, Arizona, USA, 1978 PHOTOJOURNALIST

One of America's most revered photojournalists of the twentieth century. Began taking pictures in 1933, and 1938-43 worked for the Black Star agency. By 1939 he had a contract with Life magazine, which became the start of a long but often stormy relationship. During the Second World War, worked in the South Pacific where he took some of his most famous pictures and also suffered serious injuries. In the 1950s joined Magnum, and in the 1960s and 1970s, although his popularity had waned, was still as prolific and continued to produce work of great interest. Rediscovered after his death and given due recognition.

KEY BOOK W. Eugene Smith, The Camera as Conscience (1998)

W. Eugene Smith never wanted to be just another photojournalist. He aspired to be a great communicator and storyteller. That in itself is not unusual, but what separated him from the rest was also the need to be thought of as an artist. In order to realize this goal, Smith felt that he must have total control over every aspect of picture taking. He would come up with the idea for a story, shoot it in whatever format he chose, edit the work from the contact sheets that only he saw, print it all himself and write the text to accompany the pictures. This sort of control was unprecedented at the time (and still is), and therefore Smith earned the reputation as something of a maverick - and on more then one occasion parted company with his employers. Smith is also given credit for popularizing the extended photo essay. While he was not the first, he certainly perfected it and some of these essays for Life, such as 'Country Doctor' and 'Spanish Village' are masterpieces in storytelling. In these essays, Smith is also crossing the boundaries of strict reportage neutrality. Many of the images are highly personal statements with the photographer no longer just the bystander, but clearly stage managing what is being photographed. This did not matter, said Smith, who felt that the best sort of photojournalism was one based on honesty, rather than objectivity. His pictures have been compared to classical paintings with the reality always somewhat exaggerated in the way the pictures are lit, framed and printed. In Smith's case, the myth most certainly matches the man.

A Welsh Coal-mining Town (1950)

Smith believed that a photojournalist was allowed to cross the boundaries of objectivity as long as he was honest. This appears to be the case here, where the miners are most defiantly posing for the camera and looking suitably grim, presumably under the direction of Smith. Nevertheless he does have a natural affinity with the working man.

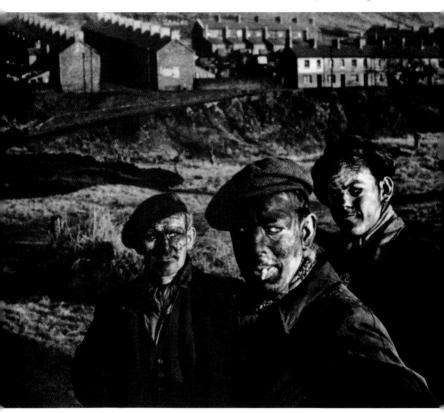

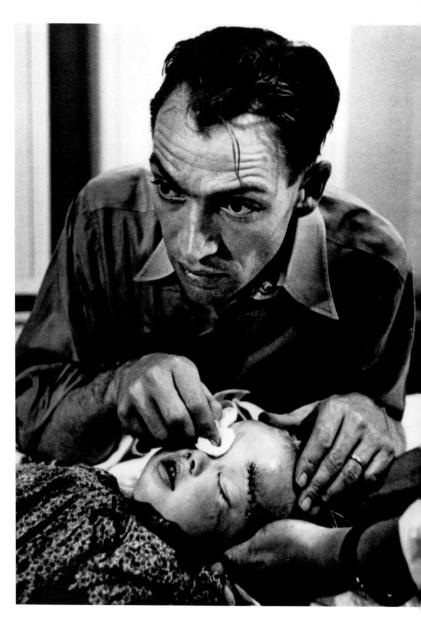

[Left] A Country Doctor (1948)

A picture from one of Smith's most famous picture essays. Dr Ernest Ceriani lived in a small town in Colorado and Smith spent weeks trailing him as he went about his business looking after the local families. This young girl had been kicked in the head by a horse.

[Below] Andrea Doria victims, New York City (1956) The Andrea Doria was an Italian liner that sank off the north-east coast of America. Smith was at the harbour when the survivors returned and the horror of what has just occurred is conveyed through the eyes of this nun - she is our witness.

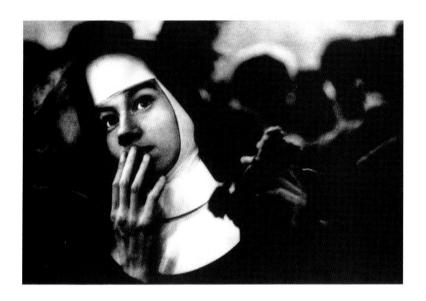

ALFRED STIEGLITZ

BORN Hoboken, NJ, USA, 1864 DIED New York, USA, 1946 ART PHOTOGRAPHER, CRITIC, GALLERY OWNER AND PUBLISHER

Member of a wealthy German-American family, Stieglitz was the guintessential amateur photographer, when that term still signified a role of high social status. Well educated (in Germany) in arts and sciences, he became a leading member of the Pictorialist movement in Europe, before returning to America in 1890 and deciding to raise the profile of photography as a visual art. His New York gallery '291', founding of the Photo Secessionists and publication of the influential magazine, Camera Work, played an important role in redefining the course of American art and photography.

KEY WORK Georgia O'Keeffe: A Portrait by Alfred Stieglitz (1977)

Alfred Stieglitz's rather overblown reputation as a photographer rests on a number of interesting photographs which bridge the late nineteenth and the early twentieth centures, but far more on his seminal role in promoting the medium as an elitist art. Probably the most interesting of the pictorialists, he avoided ethereal subjects in favour of natural scenes, convinced that it is form rather than subject that conveys emotion and meaning. His 'Flat-Iron Building' (1903) is typical of his work, and shows that Stieglitz delighted in 'difficult' lighting conditions - rain, snow, fog, the night - which he used to expressive effect. 'The Steerage' (1907) is often anthologized as a pivotal photograph because Stieglitz considered it his most important work, but his view of third-class passengers on a liner viewed from his first-class berth is a metaphor for his photographic elitism. Although he promoted Modernism through his galleries and publishing activities, Stieglitz's own work failed to become 'hard and straight'. Yet his sensual exploration of his young wife-to-be, Georgia O'Keeffe, in a series of portraits of 1917-21, and his more elusive cloud series 'Equivalents', of 1922-30, were highly influential in his own country (but not elsewhere): partly because Stieglitz was the godfather of the parochial world of American art photographty in the inter-war period.

Paris (1913)
Stieglitz preferred to photograph natural scenes and generally avoided ethereal or abstract subjects. He was also attracted to the urban landscape and liked to observe how people and buildings interacted.

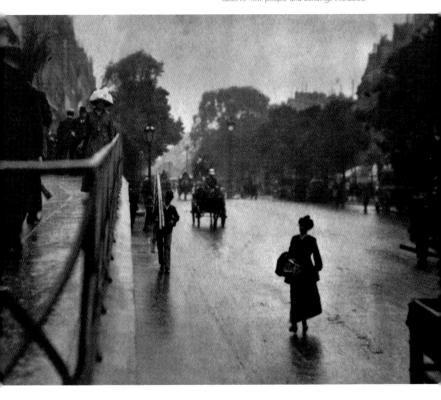

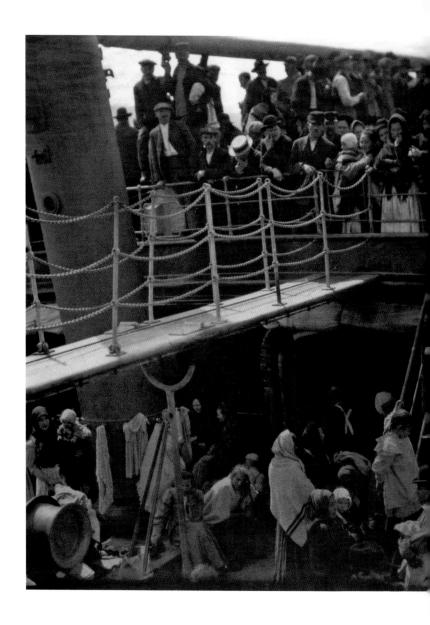

[Left] The Steerage (1907)

One of the most famous images from the early part of the century and the photograph that sealed his reputation. The view of third-class passengers viewed from his firstclass berth is a metaphor for his photographic elitism.

[Below] City of Ambitions (1910) Skyscrapers and high buildings for many early twentiethcentury photographers represented progress and industrialisation. There is a nice juxtaposition between the

buildings and the shimmering water.

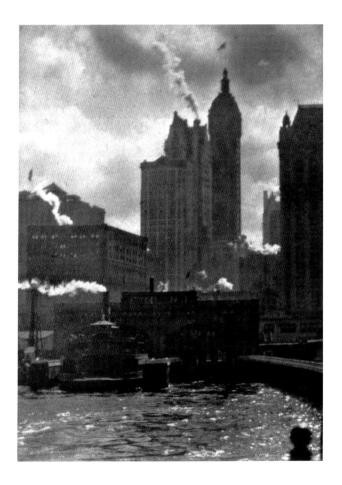

PAUL STRAND

BORN New York, USA, 1890 DIED Orgeval, France, 1976 PORTRAIT, STILL-LIFE AND FINE-ART PHOTOGRAPHER

Introduced to the medium in 1907 by the great documentary photographer, Lewis Hine, In 1912, became a commercial photographer. In 1917, met Arthur Steiglitz who dedicated an entire issue of Camera Work, a highly influential photography magazine, to Strand's street work. In the 1920s and 1930s worked for both the Mexican and US governments as a photographer and cinematographer. Travelled widely and published books on New England, France, Italy, the Hebrides, Egypt and Ghana, From 1951 until his death lived in France, as he felt that the USA had been seized by McCarthyism.

KEY BOOK An Italian Village (1997)

As an artist, Paul Strand had three lives. First, the life of a commercial photographer who was more drawn towards abstract still life and who tried to give mundane objects a resonance. The second career, which lasted for most of the 1930s and 1940s was that of socialist documentary film making, with Strand seeking to highlight what he perceived were the ills of the world. And then there was his third and most productive period, which lasted from the end of the Second World War until his death: Strand navigated the globe. taking pictures of ordinary working lives (a forerunner to Salgado's epic, Workers). Strand's approach is effectively direct. His subjects usually stand somewhat grimfaced against walls, be they stone, timber or brick, staring directly at the camera and taking centre stage in the frame with little to distract the viewer. Strand is not interested in the decisive moment, but more in the history of his subjects, where they come from and what they represent. His photography is more akin to anthropology than photojournalism. As he put it: 'I sought the signs of a long partnership that gave each place its special quality and creates the profiles of its people.' Strand was a life-long socialist and thus his belief in the innate dignity of the working man is always present in these pictures. The men and women are idealized; at times they seem no more than participants in Strand's own drama. Yet for all the polemic, there is also compassion. One of the century's more under-rated photographers.

Wall Street, New York City (1915)
The men and women are hurrying to work but they are insignificant when photographed against the backdrop of the building. A lifelong socialist, Strand would have felt uneasy about the ideology of Wall Street.

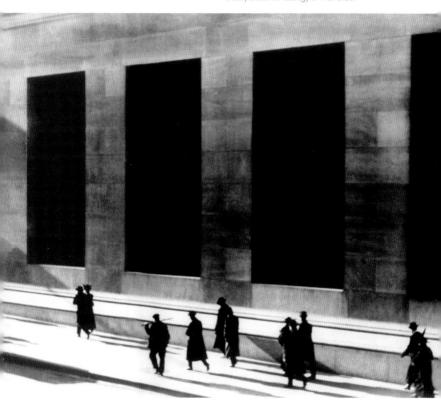

[Left] Tailor's Apprentice, Luzzara (1953)

This image has all the Strand hallmarks: the depiction of the 'common' person, the direct unflinching gaze, the subject posed against a wall and his pure, uncluttered approach to portraiture. [Below] Market Day, Luzzara (1953)

Strand revelled in the ambience and natural light of southern Europe. Here he is the casual observer watching the drama and social interaction of the market unfold before his eyes.

THOMAS STRUTH

BORN Geldern, near Düsseldorf, Germany, 1954

FINE-ART PHOTOGRAPHER

After beginning his studies at the Düsseldorf Art Academy with painter Gerhard Richter, Struth switched to the photography department, then run by famous pair Bernd and Hilla Becher. Under their tuition Struth began a series of streetscapes, selections from which formed his first solo exhibition at P.S. 1. in New York in 1978. Struth has been the subject of a number of large retrospectives, and won the Spectrum International Prize for Photography of the Foundation of Lower Saxony in 1997.

KEY BOOK Streets (1995)

'My work,' said Thomas Struth, 'is less about expanding the possibilities of photography than about re-investing it with a truer perception of things by returning to a simple method, one that photography had from the beginning of its existence.'

He put his money where his mouth is with his early series of black-and-white street scenes: taken with a heavy, large-format camera, and deserted of people, these images recall the nineteenth-century Parisian photographs of Eugene Atget. His pictures of New York in the late 70s are particularly poignant, depicting Manhattan at its nadir of financial ruin (in 'Crosby Street' the asphalt seems to have been torn up and replaced with a dirt track). Apart from looking back to the 'honest' beginnings of photography, Struth also took on board the lessons of his tutors. Bernd and Hilla Becher, and other practitioners of conceptual art. By developing series of related images over long periods and across diverse locations, he created typological examinations that allowed comparisons of phenomena on a alobal scale. Travelling to Edinburgh. Shanghai, and Tokyo to photograph cityscapes, he revealed the global impact of economic cycles - and also the cultural nuances that still differentiate our networked planet. His second series grew out of discussions with psychoanalyst Ingo Hartmann about family portraits that had been brought into sessions by his patients. The resulting project took a conventional genre - the family photo - and imbued it with conceptual rigour, as Struth travelled the world like some nineteenth-century ethnographer capturing specimens. The interpersonal relations of these sitters, and the way they present themselves to the

Grand Street at Crosby Street, Soho, New York (1978)
Desolation row: late 1970s New York is a decaying
ghost town in this image by Thomas Struth, part of a
series of international streetscapes.

camera, are just as telling and nuanced as the objects with which they surround themselves – but when viewed in series, their bodies become a strange and alien semaphore, like a familiar word repeated until it loses its meaning. Another series captures the reactions of museum visitors looking at famous artworks, such as Michelangelo's 'David', or the Pergamon Altar in Berlin. Like the family portraits,

these images are concerned with the gaze and the body – but also in this instance with art. By bringing representations of the gallery into the gallery but displacing art from its central position, Struth questions the social purpose of art institutions – unsettled, to say the least, in an age of global tourism and photographic reproduction – and brings into focus the very act of looking.

HIROSHI SUGIMOTO

BORN Tokyo, 1948 **FINE-ART PHOTOGRAPHER**

Hiroshi Sugimoto's upbringing was, like post-war Japan itself, the product of a febrile hybrid of cultures. Moving to the USA in 1970, he studied photography at the Art Centre College of Design in Los Angeles. He relocated to New York in 1974, and in 1976 began his first photographic series, 'Dioramas'. He won the Hasselblad Foundation Award in 2001, and his longstanding interest in buildings has spilled over into several architectural commissions, including a wooden Shinto shrine in the Naoshima Contemporary Art Centre, Japan.

KEY BOOK Seascapes (1994)

Reacting to the mainstream of photography in the 1960s - which fell to a greater or lesser extent within the Cartier-Bresson street-photography tradition - Sugimoto's enigmatic images transport us to another dimension. It's tempting to see manifestations of Shinto animism in his resonant photographs, but this kind of nationalist reading would overlook the fact that Sugimoto's vision extends far beyond the country of his birth - and in fact he lives mostly in New York. Sugimoto (who

cites Duchamp as an inspiration) can be compared with conceptual artists working with photography such as Ed Ruscha. These artists undermined the power of the individual image and its status as an artwork by presenting it within a series - and in doing so inspired a generation of photographers. However, Sugimoto is also post-conceptual: his images look back to the nineteenth-century tradition of pictorial photography, as demonstrated by his long exposures of the sea and his blurred images of modern architecture (his great technical mastery, too, returns his images from the anti-aesthetic terminus of conceptual art). Sugimoto's first series showed dioramas of stuffed animals and waxworks in museum displays, exploring the uncanny aspect of illusionistic art, and the troubled border between art and science - a theme pertinent to the medium of photography. His 'Seascapes' (begun in 1980) are all titled with their exact locations, but because the sea looks much the same everywhere these scrupulous labels paradoxically undermine the geographical specificity of photography. Rather than saying 'I was here' with his camera, Sugimoto asks - like a sleeper awakening - 'Where am I?', and in his mistier shots the observer is unshackled to such an extent that the sky merges with the sea, closing the perceptual gap between earth and cosmos. In another series -'Theatres', begun in 1978 - Sugimoto takes time and narrative as his themes.

Sea of Galilee, Golan (1992)
Sea and sky merge in a seamless tonal continuum in Sugimoto's mistier seascapes, harking back to the romantic blur of Pictorialist photography.

Turning his lens on cinema screens, he exposes his 4x5 plate for the entire duration of a film's running time until the silver screen is wiped to a pure white rectangle: information becomes its opposite. Similarly perverse are his unfocused images of Modernist architecture, which transform

the hard-edged buildings of Mies van der Rohe (among others) into chiaroscuro abstractions. Recalling Edward Steichen's photograph of the Flatiron Building in New York, these pictures critique the rationality of Modernist architecture, and the vaunted objectivity of his own medium.

WOLFGANG TILLMANS

BORN Remscheid, Germany, 1968 FASHION, SOCIAL DOCUMENTARY AND FINE-ART PHOTOGRAPHER

Tillmans first came to Britain to study photography under Nick Knight at Bournemouth College of Art in 1990. He moved to London in 1992, where he worked for fashion magazines while exhibiting his work in galleries. He has taught at the Hochschule für Bildende Künste in Hamburg, and in 2000 he won the Turner Prize. He has run a gallery, Between Bridges, since 2006.

KEY BOOK If One Thing Matters, Everything Matters (2003)

Seemingly artless snapshots of his friends, clubbers, and boys on the gay scene catapulted Wolfgang Tillmans to underground celebrity in the early 1990s. Intimately associated with magazines like iD and The Face, Tillmans followed in the footsteps of his teacher Nick Knight, whose deliriously coloured shots had graced the same publications since the 1980s. However, Tillmans tempered Knight's glossy aesthetic with a grimy, flash-soaked nonchalance borrowed from

Nan Goldin, Tillmans' oeuvre comprises much more than just fashion photography: he has also shot a conceptual-photographyinformed series of Concorde coming into land near Heathrow (displayed as a grid of 56 images) and huge abstract prints produced without a camera that remake the photogram experiments of Man Ray for a digital age. Tillmans often displays his prints in a patchwork of different sizes, pinned directly to the wall. If this seems another nod to the conceptual photographers who tried to de-aestheticize the photograph as an art object in the 1960s, it can also be read as a fond homage to the bedroom walls where his magazine shoots, torn from the pages of magazines by a generation of teenagers, have been pinned: a typically indefinable combination of high art and pop culture. Taking this collage approach further, Tillmans has also installed his images on plexiglass-covered tables alongside press clippings, packaging, and other ephemera. This was inspired by the realization that this is how he begins editing all of his works; and by displacing the photograph from the gallery wall, the viewer is encouraged to share the creator's critical approach to the image. Titled 'Truth Study Center', this table-top installation - first shown in 2005 and revived since with topical alterations – was partly a response to the aftermath of 9/11, when Tillmans "realized that all the problems that the world faces right now arise from men claiming to possess absolute truths."

The Cock (Kiss) (2002)
The awkward ecstasy of a million teenage nights out are distilled in the sweaty urgency of Tillman's 'Kiss'.

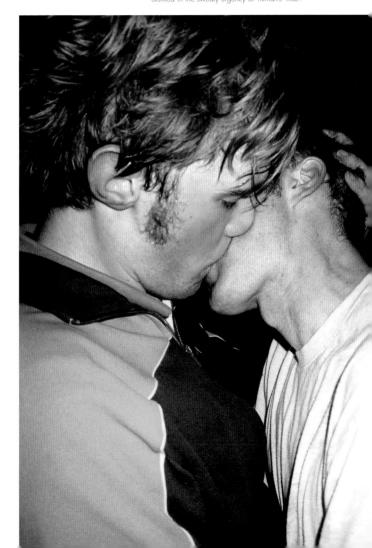

SHOMEI TOMATSU

BORN Nagoya, 1930 SOCIAL DOCUMENTARY

Self-taught, Tomatsu's first photographic job was as a staffer for Iwanami Photographic Library in 1954. In 1959 he had his first solo show at the Fuji Photo Salon in Tokyo, and the same year he co-founded the avant-garde photo agency Vivo. In 1960 he was asked to photograph Nagasaki for a campaign against nuclear weapons; this resulted in his seminal '11:02' series. In 1966 he taught at the Tokyo School of Fine Arts. He has been exhibited worldwide, including a major retrospective in San Francisco in 2006.

KEY BOOK 11:02 Nagasaki (1966)

Occupied Japan presented a panorama of devastation, denial, and cultural imperialism to its inhabitants. Like many of his countrymen, buoyed up by the economic miracle of the late 50s, Shomei Tomatsu – regarded as the godfather of Japanese photography – chose to ignore the painful past: but on assignment in

Nagasaki he was confronted by the damaged survivors of 1945. His most famous shot, 'Melted Bottle, Nagasaki, 1961', shows a display in the small memorial museum in that city. Contorted like one of Michelangelo's prisoners, the bottle seems to twist in agony from the heat of the atomic blast. Tomatsu also photographed the faces of survivors of the atomic bomb, similarly transformed by their exposure to radiation, and the face of a wristwatch poignantly stopped at 11:02 - the time of the explosion and also the title of this series. But time had not stopped for Japan, and Tomatsu – a pivotal figure in Japanese photography - also documented the rapid changes occurring around him. His series 'Chewing Gum and Chocolate' (begun in 1958) shows life around the American bases - a topic of grim fascination to the Japanese, who often protested the military presence of their conquerors. The ambivalence of Tomatsu's approach is reflected in the choice of his title: chewing gum and chocolate were both rare commodities in post-war lapan, and their dispensation by visiting Gls did much to soften popular attitudes towards Americans, However, they also dispersed tooth-rotting and promiscuous American culture throughout a formerly closed society, now turned prostitute for the price of a stick of gum. One image in the series shows a black sailor standing beneath English bar signs, while in the foreground a young

Melted bottle, (from the series 'Nagasaki 11:02') Nagasaki (1961)

The beautiful tonal gradations of Tomatsu's black and white still life make for a shocking aestheticisation of (implied) violence.

mixed-raced girl blows up an enormous transparent balloon: sex between Japanese and Americans was a hot topic at the time, and Tomatsu was unflinching in his portrayal of this controversial subject. In other series like 'Protest, Tokyo, 1969' and 'Eros, Tokyo, 1969', he showed the effects of this encounter with the West: the political unrest and sexual experimentation of a younger generation

challenging the norms of traditional Japan. Tomatsu's work was often contrasted with the photography of his rebellious juniors, especially the Provoke Movement (including Daido Moriyama), but in retrospect he seems more like a father figure to these provocateurs: indeed, he collaborated with Moriyama on the founding of the Workshop Photography School in Tokyo in 1974.

JEFF WALL

BORN Vancouver, Canada, 1946 FINE-ART PHOTOGRAPHER

After studying and teaching art history for many years Wall began to take photographs in 1977, and he installed his first light-box image, 'The Destroyed Room', in the window of the Nova Gallery a year later. Since then his work has been exhibited in numerous solo shows, including a major retrospective at the Palais des Beaux-Arts in Brussels in 2011. In 2002 he was the recipient of the Hasselblad Foundation Award.

KEY BOOK Jeff Wall: Catalogue Raisonné 1978–2004 (2005)

Despite our long awareness of photographic manipulation by dictators like Stalin and Mao, and the obvious impossibility of the airbrushed bodies adorning fashion magazines, we still credulously believe that the camera never lies. Jeff Wall undermines the medium's vaunted objectivity by building elaborate

sets or using models to stage situations. His staged shot 'Mimic' (1989) looks deceptively like documentary. It seems to capture one of those "decisive moments" so beloved of street photographers: a white couple walk past an Asian man on the sidewalk, and as they pass him. the white male stretches his eyelid with his middle finger in an apparently racist gesture. Is he the mimic of the title? Or is the photograph itself, which recreates reality but does not objectively capture it, the mimic in question – a mimic equally full of prejudice and distortion? As well as critiques of his own medium, Wall drawing on his extensive knowledge of art history - has created numerous shots developing themes relating to the art of the past. His 'Picture For Women' (1979) is a kind of homage to Manet's great painting 'Bar at the Folies-Bergère', which hangs in the Courtauld Institute where Wall studied. However, unlike Manet - who reflects the viewer in the mirror of his Parisian bar - leff Wall includes the artist and his camera in the image. This could be a polemical argument for the status of the photographer as artist, but it also seems like another dig at the supposed objectivity of the photograph (can the photographer ever truly be outside the frame?). Since the 1990s. Wall has furthered his illusionism by using digital imaging techniques to create seamless composite images from hundreds of shots. The results can be deceptively naturalistic, or strikingly

Mimic (1982)
Transparency in lightbox, 198 x 228.6 cm.
Apparently a typical street-photography snap of a 'decisive moment', this is actually a carefully staged scenario. But who is the mimic here?

surreal – as in his gruesome joke, 'Dead Troops Talk' (1992), in which an Afghan battlefield full of Russian corpses is reanimated to converse with theatrical gestures. His technical innovations, complex compositions, painstaking working methods (some of his images have taken over a year to complete), and advertising-style presentation on light boxes, have all had an enormous influence on a younger generation of photographers such as Andreas Gursky.

Picture for Women (1979)
Transparency in lightbox, 142.5 x 204.5 cm.
By reflecting his subject (and himself) in a mirror, Wall confuses the places of the viewer and the artist in this homage to Manet's Bar at the Folies-Bergère.

WEEGEF

(ARTHUR H. FELLING)

BORN Zloczwe, Poland 1899 DIED New York, USA 1968 PHOTOJOURNALIST

Weegee virtually invented a genre of urban street photography that focused on New York's lurid and often violent underbelly. So nicknamed in deference to the ouija board because it seemed that he was able to be at the scene of a crime or accident before it happened. (In 1938 he even received official permission to install a police radio in his car.) The 1930s and 1940s were Weegee's decades: his work was seldom out of the tabloids, he was the photographer who showed a side to America that everyone not necessarily liked or understood, but nevertheless felt compelled to view. Much imitated, but never bettered. Later went to Hollywood as a film consultant and bit-part actor.

KEY BOOK Weegee by Weegee (1961)

If ever there is a blueprint for the obsessive, hyperactive photojournalist relentlessly pursuing the story then surely it is Weegee. His subjects were often harrowing and squalid: suicides,

violent crimes and catastrophic fires. These images were obtained through a combination of sheer will, a strong voyeuristic tendency (a prerequisite for all great photojournalists) and a huge network of contacts, most of them within the Manhattan Police Headquarters. On many an occasion, the police took the crime that much more seriously if Weegee was present snapping away. Strangely, for a photographer so intent on conveying a few home truths about a far-from-perfect society, marred by violence and poverty, his images were highly stylized. The Weegee trademark is strong, almost overbearing, flash light fixed on to a 12.5×10 cm 15×4 in) camera giving the pictures a depth and dramatic contrast between light and shadow; he predated film noir. There is also the classic Weegee crop. exaggerating the scene and giving it an even more hyper-real spin. But perhaps most contentious is the issue of whether he stage-managed some of his more vivid pictures for dramatic effect: for example, posing a corpse to help the composition and impact of a photograph. Like much of what he photographed, this mystery remains unsolved. His collaboration with the police department lasted for about ten years, and during that time he produced over 5,000 photographic reports, making him one of the most celebrated figures of his day and in so doing, creating the cult of the photographer.

She Feels the Beat (c. 1944)

A captivating photograph full of atmosphere and life.

It is taken in a deeper half, but it could write each to be

It is taken in a dance hall, but it could quite easily be a Baptist church. Note Weegee's uncanny ability to crop a picture down to its bare essentials.

[Left] Murder at the Feast(1939)

A murder at the feast of San Gennaro. Police take over at the scene of a gangland killing on Mulberry Street, Little Italy, New York. The two victims were Joseph 'Little Joe' Cava and Rocco 'Chickee' Fagio. Note how the murders are turned into a public spectacle played out in the streets. Weegee is as interested in the on-lookers as he is in the actual slaying.

[Below] The Line Up (1939)

Nine black men in a police line-up with their backs to the viewing window. Weegee was on first name terms with many high-ranking police officers, which explains why he was granted almost unlimited access to photograph the police going about their daily business.

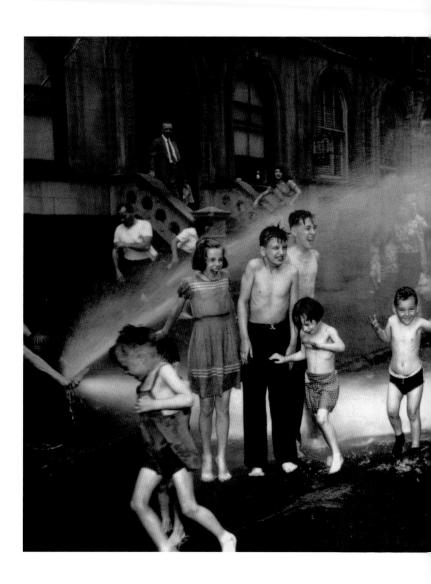

New York Summer (1937)
Children cool down in the spray from a fire hydrant on a hot summer's day in New York's Lower East Side.
Weegee did not just photograph violence and sleaze; he also had an affinity with New York's more gentle and innocent side.

MADAME YEVONDE

BORN Yevonde Cumbers, London, 1893 DIED London, UK, 1975 FINE ART/FASHION/PORTRAIT PHOTOGRAPHER

Set up her own photographic studio in 1914, and in 1922 took the official engagement photo of Lord Mountbatten. Her work appeared regularly in The Sketch and Tatler. In the late 1920s. started her experiments, with Dr D.A. Spencer, with colour photography and the Vivex process, a modification of the Carbro process. In 1932 she became the first photographer to exhibit in colour. In 1935 she took pictures of society women as mythical goddesses and in the 1940s and 1950s she worked outside London for Homes and Gardens. Her work was rediscovered by a new audience after major shows at the National Portrait Gallery, London and Royal Photographic Society in the 1990s

KEY BOOK Madame Yevonde (1990)

Technical efficiency is commonplace in our modern world, but the man who will use his imagination is a rare creature, said Madame Yevonde who had both. as well as a lifelona interest in female emancipation. Her work spans over sixty years, comprising classic black and white portraits and still lives, but it is her experimental colour work for which she is best remembered. She started out as a fairly traditional society photographer but by the end of the 1920s had become bored with black and white. Colour excited her, it stimulated her imagination and she became a rapid convert to the medium. Her technique consisted of taking black and white pictures through red, blue and green filters and also putting colour filters over her lights and lens. She was also fond of mixing and matching colours, producing an almost hallucinogenic quality to her pictures. Never was this surreal edge more evident than in her 'Goddesses' series Here Madame Yevonde depicted society ladies and debutantes as mythological figures: for example, the Duchess of Argyll became Helen of Troy. Even more strange is the picture of another society woman as Minerva, pictured with a revolver and an owl. In the hands of anyone else these pictures would quite easily be dismissed as high camp, but Madame Yevonde had a superb compositional eye allied to technical wizardry. If she were alive today, no doubt she would have embraced digital imaging with the same enthusiasm.

Mrs Edward Meyer as Medusa (1935)
This is part of the Goddesses series, in which Madame
Yevonde depicted society ladies as mythological figures. It
has never been established whether the snake is real or
not, but the picture still has plenty of bite.

[Left] Lady Milbanke as Penthesilea, the Dying Amazon(1935)

In the hands of anyone else this Goddesses series could be dismissed as no more than high camp, but Yevonde had such a mastery of colour and such belief in her abilities that she manages to pull it all off. The series also appealed to these rich women's vanity.

[Below] Lady Ann Rhys as Flora (1935) Again the strength of this picture lies in its subtle use of colour. In fact the colours are so rich and so lush that this picture could quite easily have been taken in the 1990s.

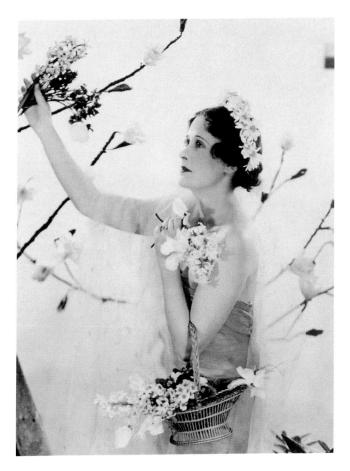

PICTURE CREDITS

The publishers would like to thank the following sources for their kind permission to reproduce the pictures in this book:

Allsport UK Ltd. 67-69

©1955, Aperture Foundation Inc, Paul Strand

Archive: 245-247

© Association Des Amis de Jacques-Henri

Lartigue: 153-155

Bridgeman Art Library: /Hilla & Bernd Becher/

Museum of Fine Arts, Houston: 35, /©
Eggleston Artistic Trust. Courtesy Cheim &

Read, New York: 71-73, /Candida Höfer/

The Israel Museum, Jerusalem/Committee of the

American Friends of the Israel Museum: 113, / Graciela Iturbide/Museum of Fine Arts, Houston,

Texas, USA / Funds provided by Isabel B. and Wallace S. Wilson: 123, /@ Hiroshi Sugimoto,

courtesy Pace Gallery: 251

Camera Press Ltd. 30-33, 127-129

Collections 85-87

Commerce Graphics Ltd, Inc. 12-15

Corbis: 59-61, 147, /Ansel Adams Publishing

Rights Trust: 16-19

©1978 The Imogen Cunningham Trust 54-57 Courtesy George Eastman House: 50-53, 106-111, 241-243

Courtesy Fraenkel Gallery, San Francisco 81-83 ©Robert Frank: From The Americans; courtesy

Pace/MacGill Gallery: 79

Getty Images: 39-41, 96-101, 103-105,

261-265

Nan Goldin Studio: 89-91

Hamiltons Photographers Limited: 115-117,

121, 135-137, 179-183

Robert Harding Picture Library/Minden Pictures: 149-151

The J.Paul Getty Museum, Los Angeles: 37,

209-211

Nadav Kander Studio: 125

Frank Lane Picture Agency: 119

Library of Congress, Prints & Photographs
Division: FSA/OWI Collection (Reproduction no:

LC-DIG-fsa-8b148451: 185

Magnum Photos: 20-25, 43-45, 46-49, 75-77, 161-163, 171-173, 187-189, 194-199, 201-

203, 213-215, 237-239

Courtesy Robert Mann Gallery: /@O.Winston

Link: 157-159

© Mary Ellen Mark: 164-169

Matthew Marks Gallery, NYC: 93-95

Courtesy Metro Pictures NY 11, 229-231 © Ministère de la Culture-France: 131-133

NK Image Ltd: 143-145

Network Photographers/Amazonas 223-225, /

Rapho: 63-65, 217-221

Helmut Newton/TDR: 175-177

©Phototheque des Musées de la Ville de Paris 26-29

Rankin Photography: 191-193

Royal Photographic Society: 267-269

© Die Photographische Sammlung/SK Stiftung Kultur - August Sander Archive,

Cologne; DACS/Tate Images: 227

© Stephen Shore / Art + Commerce: 233-235

Courtesy Sports Illustrated: 139-141

© Thomas Struth: 249

Wolfgang Tillmans: Image courtesy Maureen

Paley, London: 253

Shomei Tomatsu: Courtesy of Studio Equis: 255

Visages Syndication: 205-207

Jeff Wall: 257-259

Every effort has been made to acknowledge correctly and contact the source and/or copyright holder of each picture, and Carlton

Books Limited apologises for any unintentional errors or omissions which will be corrected in future editions of this book.

Carlton Books Ltd. would like to extend a special thank you to all the photographers for their help and co-operation in this project.
Thank you also to:
Stefane Gaudion, Donation Andre Kertesz

Michael Houlette, ©Association des Amis de Jacques-Henri Lartique

Helaine, Commerce Graphics Ltd, Inc. Elizabeth Partridge, Imogen Cunningham Trust

Janice Madhu, George Eastman House Meredith Lue, Falkland Road, Inc.

Katherine Higgins for Robert Frank

Renee for Nan Goldin

Leigh, Hamiltons Photographers

Emma for Nick Knight

Hamish Crooks, Magnum Photos

Lisa, Robert Mann Gallery Leslie, Matthew Marks Gallery

Jeff, Metro Pictures

Pauline, Rankin Photography

Karen, Sports Illustrated

Barbara, TDR

Oliver Evans at Maureen Payley for Wolfgang

Tillmans

Kerri, Visages Syndication

Evan Lee at Jeff Wall's studio

Text on pages 34–35, 70–73, 78–79, 112–113, 122–123, 184–185, 226–227, 232–235, 248–249, 250–251, 252–253, 254–255 and 256–259 contributed by Tom Wilkinson, 2013

ACKNOWLEDGMENTS

This book could not have been completed without the invaluable help and support of my cowriter Peter Hamilton. Peter wrote the critical appraisals for the following photographers: Berenice Abbott, Eugène Atget, Cecil Beaton, Margaret Bourke-White, Henri-Cartier Bresson, Alvin Langdon Coburn, Imogen Cunningham, Robert Doisneau, Lee Friedlander, Fay Godwin, André Kertesz and Henri Lartigue. I would like to thank Julian Rodriguez for his advice and for his reflections on the following photographers: Edward S Curtis, Nan Goldin and Cindy Sherman.

I would also like to acknowledge the contribution of my American colleague Holly Hughes for her perceptive Foreword. Words of wisdom and encouragment also came via my former colleagues at the British Journal of Photography: Darron Hartas, Sean Louth, Michael Moore and Jon Tarrant.

Thank you also to Charles Swan of The Simkins Partnership, Sara Rumens from Magnum and Anna Starling of The Photographers Gallery. A debt of gratitude is also owed to my editor at Carlton Books Penny Simpson for her guidance and cool head, Sarah Larter who got me on board and Lorna Ainger for picture research.

Finally, I would like to thank my parents Abe and Aviva for their assistance and understanding and Polly for her patience and support.